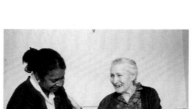

Sharing the Experience

How to set up and run arts projects linking young and older people

A Magic Me Handbook

by Susan Langford
and Sue Mayo

photographs
by Lisa Woollett

This book is dedicated to all those people who have taken part in Magic Me and especially to the memory of Ellen, Emil, Florrie, Lily, Pat and Rose.

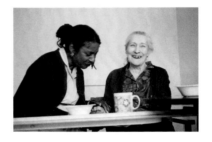

Sharing the Experience
How to set up and run arts projects linking young and older people

Susan Langford and Sue Mayo assert the right to be identified as authors of this work in accordance with the Copyright, Designs and Patents Act 1988.

First published in the United Kingdom in 2001 by: Magic Me

118 Commercial Street
London E1 6NF England
Telephone 020 7375 0961

Copyright © Magic Me 2001.
Photographs copyright © Magic Me and Lisa Woollett 2001.
Additional photographs Anthony Lam (pages 3 and 22)

ISBN 0-9538680-1-X

Book text set in Bell Gothic
Design: idz
Print: Aldgate Press

Contents

Introduction

Sharing the Experience has grown directly out of the experience of more than ten years of Magic Me projects. Through a wide variety of creative work with young and older people, in many different settings, we have found certain elements which seem to apply across the board, both practicalities and principles. Magic Me receives many requests for information and advice and we are invited to do more projects than we can realistically take on. So we welcome the opportunity to try to distil and share our experiences through this book.

The writing of the book was made possible by a major grant from the Community Fund, which also funded a series of inter-generational arts projects with groups across the London Borough of Tower Hamlets. Work focused on how best to run inter-generational projects with four growing groups of elders in the area: elders with dementia, frail elders living in nursing homes, Bengali elders and Somali elders.

Four consultants were recruited to help us research the needs of these groups, design and set up appropriate projects and monitor and evaluate how they went. Specialist community artists planned and led the practical projects, which included the writing of a bilingual book of stories, printing silk-screen banners and art works, singing workshops, video animation, weaving, drama, creative writing, puppetry and painting workshops.

From the start our plan was to record the programme in words and pictures and to write a handbook drawing on these and other Magic Me projects. No one book can cover all eventualities. Whilst we hope that we have provided a thorough basis from which to work, we remind you to expect and look forward to the unexpected, which is often the most exciting part of the work.

Susan Langford
Sue Mayo

With thanks to

the consultants who supported us in so many ways:
Angela Cotter, Emdad Haque, Linda Rose, Ahmed Said;

our Arts Development Worker, Imogen Ashby;

all the Magic Me artists and consultants who contributed to the making
of this book: Kinsi Abdulleh, Mukul Ahmed, Kay Aplin, Shamim Azad,
Vivien Ellis, Tess Garrett, Kathryn Gilfoy, Kate Holdom, Shaddin Khasru,
Penny Lindley, Athena Matheou, Teresa Osbourne, Mahfuza Rahman and
Dilys Stinson;

the artists and other organisations who worked on collaborative projects:
Kath Bristow and Tony Minion of Cloth of Gold, Sean Taylor of Eastside,
Andrea Finn and Roger Hargreaves of the National Portrait Gallery, Claire
Baker and Rohan Taylor of Studio 3 Arts;

the Community Fund and London Arts for funding this publication;

the Task Force Trust for supporting its marketing and promotion.

Those taking part

The many Magic Me groups and venues who
contributed ideas or allowed us to use their
photographs and art works for this book.

Ben Jonson School
Blue Gate Fields School
Charles Dickens School
Columbia School
Hermitage School
Fitzgerald Lodge
Lansbury Lodge
Lawdale School
Magic Me Holiday Club
Manorfield School
Mile End Hospital
Northwold School
Oaklands School
Ocean Estate Tenants' Association
Old Palace School
Oxford House
St Hilda's East Bengali Day Centre
Sam and Annie Cohen Day Centre
Silk Court
Stepney Jewish Community Centre
Susan Lawrence School
Tate Modern
The Green
William Guy House

3

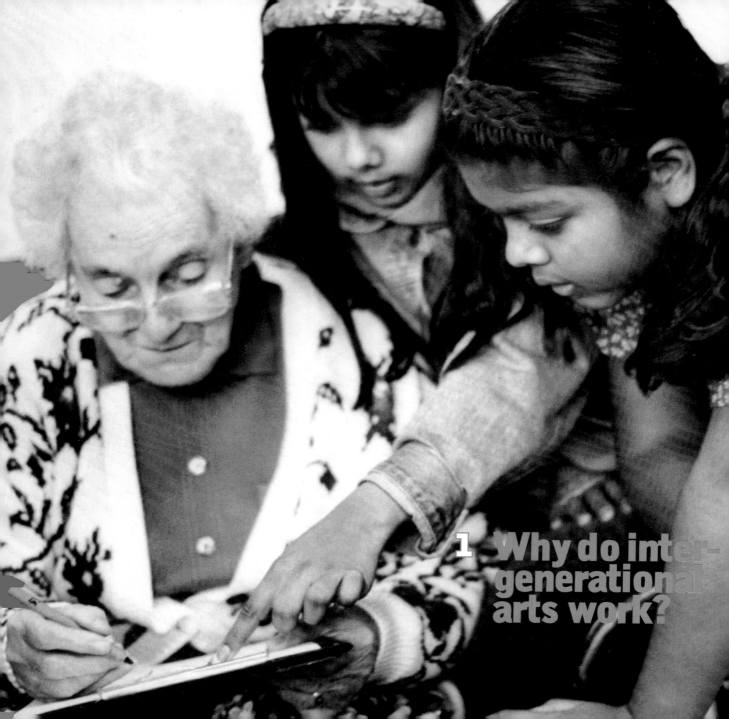

1 Why do inter-generational arts work?

At the heart of Magic Me is the basic premise that all people are individuals with a capacity for growth and change wherever they are within the natural process of living, ageing and dying.

Magic Me introduces a new dynamic to the people and places with whom it works, believing that young people and elders can, by coming together, benefit one another in ways which would be impossible if they worked separately. The two groups have much to offer one another. Older people can be a resource for younger ones, able to bring a sense of perspective to the difficulties of growing up. Young people bring energy, idealism and fresh enthusiasm. Where young and older people come together for shared creative activities there will be:

an exchange of experience, of skills and knowledge, of ways of being and behaving

an opportunity to discover the real people behind the stereotypes

a chance to value the differences between people, as well as to discover common ground

a change of pace and energy for all the participants

an excuse to play and to experiment, to be creative, to make a fool of yourself

non family members with whom to build a relationship

the excitement of creating something together, from a poem to a painting, a photo to a play

Whatever your motivation or interest in inter-generational work, and whatever kind of project you are considering, careful planning and preparation will be needed to make it happen. This book will take you through both the practicalities and the principles underlying the work, at each stage of the process. Most of Magic Me's work is with elders living in residential homes or using day centres, and with school pupils. However this book can be used to set up projects in a much wider variety of settings.

The most vivid way of answering the question, 'Why do inter-generational work?' is to look at the responses which have come from people who have been part of Magic Me projects across the years. These words are culled from a wide variety of project participants. They are not all direct quotes, but they do represent real voices.

Principles of inter-generational arts work

The work anticipates and draws out the diversity of experience, outlook, knowledge and lifestyle of people of different ages.

In an inter-generational project all the participants, leaders, and staff involved will be aware of age, theirs and others. This is an ideal point from which to explore stereotypes, taboos, illusions, the 'politics' of age. This kind of exploration can be energising and liberating for everyone involved.

The arts activities are designed to work better with both groups working together than they would have been with only the young people or only the older people

Nobody is demeaned by the activities, ie. adults are given opportunities to play and be child-like, but not made to be childish; children are not brought in just to entertain.

All contributions are equally valued.

I noticed that a lot of people in the Day Centre sat by the window which overlooked the playground of the Primary School next door. They always seemed to be complaining about the noise level, about the children's behaviour. The kids used to kick footballs against the wall below the window, and occasionally there were shouting matches through the window about this. I wondered whether we could build a bridge between the adults and the children by bringing them together, so that they got to know one another and felt less suspicious. We invited a local arts organization to work with us, and after discussion with the school and the clients here they suggested a visual arts project. A year later we have made a real difference to the relationship between the two groups. They have created beautiful mosaic panels for the School and the Centre, other visits between the adults and the children are being organised outside the project and instead of shouting through the window, they wave.

Social Worker attached to Day Centre

I couldn't believe how different some of the students were when they visited their friends in Holland House. Even the shyest ones seem to find a new confidence, talking and laughing with their partners; enjoying learning new skills, and enjoying being able to teach an adult something.

Class teacher, Secondary School

A lot of our clients feel they have lost their role, that they are no longer useful. They really blossom when they feel they are helping the children, when they feel that someone wants to listen to them.

Activities Organizer, Nursing Home

I realized how little the adults here knew about each other. When the young people were asking them questions I could see the whole room listening carefully to the answers, and when they had gone home picking up the threads of the conversation: 'I didn't know you had lived in Stanley Street...' 'When did you work in the Biscuit Factory?' It strengthened the links between them, and gave us a chance to get to know them better too.

Care Assistant, Day Centre

The children were very brave, they introduced themselves and asked us questions. It takes a lot of courage because we are old and some of us are not very well. It was always a pleasure to see young people. We told them our stories, how we came to this country, and what we did back home. They showed us what they'd written and, on the last day, they acted it out. When the children came the time passed so quickly. It's good for us to mix with young blood and it's good for them to have activities with us old people.

Elder, Bengali Day Centre

An inter-generational group who had already been meeting for some time were invited by a theatre company to be part of a big city-wide project. They had got into a bit of a rut, but this drama project provided a new stimulus for everybody. All the scenes which we were creating were based on the actual words of all the participants, and it was very moving to see 14 and 15 year olds playing men and women in their eighties, who would coach them to make sure they got everything right. The young people carried the stories of their adult partners into the performance with great respect and sensitivity.

Drama animateur

I like going to visit John and the others every week. The staff thought we might not be able to understand John because of his stroke, but we can, and he makes me laugh when he acts out words with his hand. Last week I held the video camera for him while he filmed the group, and this week I'll be one of the filmers.

10 year old

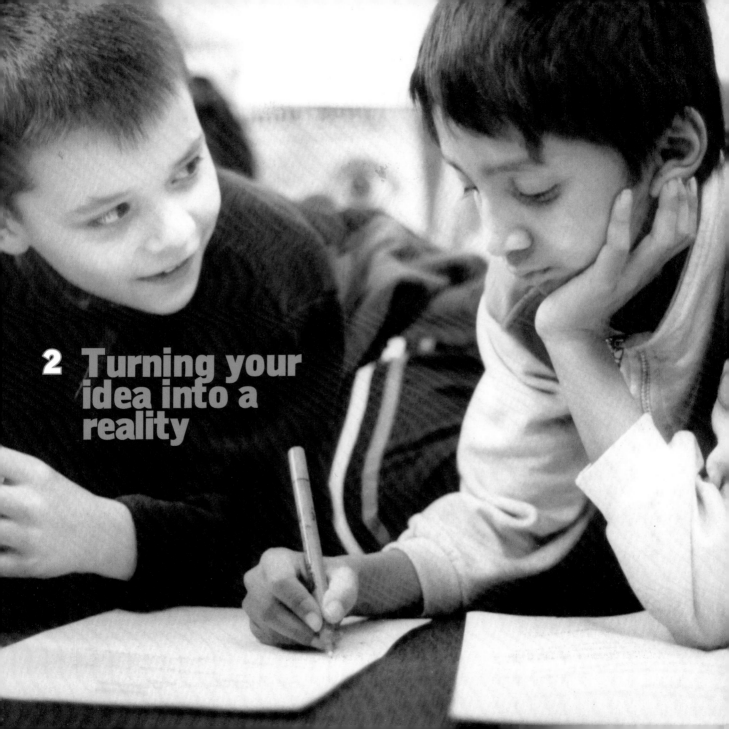

2 Turning your idea into a reality

This section of the book will help you to think in detail about what you hope the project will achieve, what you will need to make it happen, what you have to offer or contribute, what you would like from others and how to find people and places with whom to work.

Any inter-generational arts project will include: young people or children; older people; at least one person or an organisation with relevant arts skills and experience. You probably already know, or are yourself, one of these three. You may need to research and approach the other two, or may have a good idea who they are. Before you start talking to other people though, you need to do some thinking on your own.

Practicalities

Why?	What do you hope to achieve?
	How will the participating individuals and groups benefit?
Who?	Who will participate in the activities?
	Who will plan and lead them?
What?	What will everybody do?
	Which artform or activity would best suit your situation?
Where?	Where is the best place to run the activities?
How much?	How much will it cost to carry out your plan?
	What costs do you need to include in your budget?

To focus your ideas the next five sections consider these key questions.

Section 8 is about how to build good working relationships with other organisations as you find the answers.

What next?

As you begin to plan your project, you will probably find yourself going back and forth between these questions, finding general answers at first, then getting gradually more detailed. This process can feel more like going in a circle or a spiral than a straight line. Give yourself plenty of time. It may take six months to organise everything before any young and older people meet. Schools and other organisations with set timetables of work need lots of notice. Some make plans in June for the whole of the next academic year, from September to July.

Don't do it all yourself

Be sure to involve others in your thinking and planning from the outset. Who you need to consult will depend on how and where you work. In your own workplace it might include: young and older people, colleagues at all levels, your manager, committees or other planning groups.

Principles

Be realistic, but don't forget your dreams.

Be honest. Can your room really hold 30 people, or is it wishful thinking?

Be flexible. Be ready to adapt your plans as you find out more about those taking part, and as the project unfolds.

Communicate clearly yourself and ask questions when you are not clear what others are saying or doing.

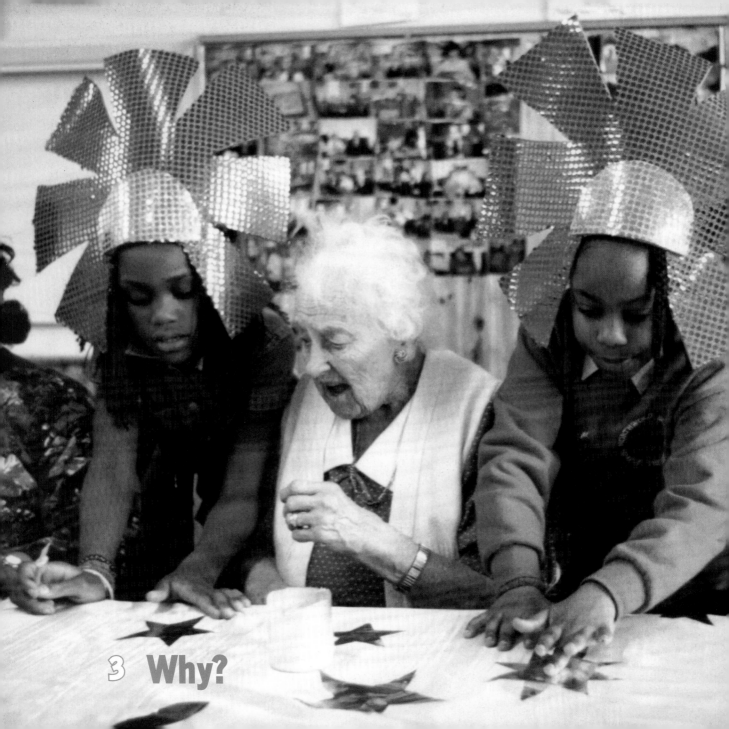

3 Why?

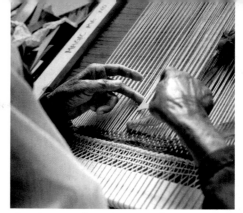

This section will help you clarify your aims for the project.

What do you hope to achieve?

A successful inter-generational arts project will benefit a variety of different people, in different ways, at the same time. Before you start planning, you will need to consider the potential benefits for all those involved, including the staff and artists.

It is easy to assume that other people think the same as you and have similar priorities. Discussing your motivations with colleagues or with potential partners in the project may reveal differences of opinion or emphasis which will need clarifying and taking into account as you plan together. Some aims may clash, or be unrealistic and have to be dropped.

It can feel restrictive to have set aims at first if you are not used to working in this way, but once decided with all the partners your chosen aims will guide you through the project, ensuring that everyone is working in the same direction. And aims can always be changed if, in the light of experience, something becomes really inappropriate.

You need to be sure that the activities you plan are best done with an inter-generational group, rather than with the young people or adults on their own. In our experience the best inter-generational projects are where both parties both give and receive, rather than being weighted on one side and where they could not have done so well, without the other group. This balance may be achieved over the lifetime of the project, rather than at every meeting. Sometimes children and elders may need time to work separately, to work at different paces or skills levels, or with different knowledge.

For instance on one photography project nursing home residents and secondary school pupils met every week to take portraits of one another, aiming towards a small exhibition. At first, with greater confidence and experience of cameras, pupils tended to volunteer quickest and hog the equipment, leaving residents learning much more slowly. Two additional 'adults only' sessions meant the older people could relax and learn at their own pace, resulting in some very good photos and more confident participants, able to demand their share of time and equipment in the next joint session. Pupils recognised that although still slower, the adults were just as skillful and interested as they were and became prepared to work with them as equal partners.

A story about weaving

One Magic Me project brought together two groups of people who seemed to have one thing in common: an interest in textiles and art. A group of older Somali women, who met regularly to learn English at a community centre, were keen for an opportunity to practice their traditional craft weaving skills and greatly enjoyed the first stage of the project, a series of workshops for their group led by a Somali textile artist and a weaver. The two artists also worked with a group of local school pupils, Bengali and white, who were studying GCSE Textiles.

The second stage of the project brought everyone together so they could exchange skills and techniques. Instead the two groups worked side by side in the same room, getting on with their weaving, but never getting further than 'hello' and 'goodbye' Lack of a common language was undoubtedly a barrier, but most importantly, people did not have to communicate to undertake the activity as it was set up. The women were happy to be weaving; the young people wanted to complete their coursework and get a good mark in their exam. Some good art works resulted but the effort invested in scheduling and planning was not repaid, because no 'extra' benefits came from the joint working and it was not really 'inter-generational'

11

To build a lasting beneficial relationship between young and older people.	To encourage older people to understand and respect young people in the community	To enable our organisation to build links with others in this community.
To help individuals be more confident in social situations and find new ways of communicating with people they don't know well.		To give individuals a chance to experience new activities and artforms and to learn new skills.
To have fun and to 'lighten up' a bit.		To bring a change of pace and energy to our regular programme of activities.
To get young and older people to work together on an issue or development in their area, which affects them equally.		To give our staff new ways of working with the clients, pupils or members.
To give older people a chance to pass on skills and knowledge to younger people.		To give young people a chance to pass on skills and knowledge to older people.
To celebrate the skills and strengths of older and younger people.	To encourage young people to understand and respect older people in the community.	To create an artwork, video, book, mosaic... which people can enjoy for a long time.

Exercise: Aims of the project

1. Photocopy the adjacent page and cut up the copy into separate boxes.

2. Choose any aims which you think apply to your project and put the others to one side.

3. If one of your aims isn't listed, write it in one of the empty boxes, or adapt one of these suggestions to suit your idea.

4. Arrange your chosen aims in order of importance, starting with the most important. (You can have two aims with equal importance but don't do this too often or to avoid difficult choices!)

5. Now ask your project partners to do the exercise and see what they are hoping for.

Principles

Clear shared aims are vital when different organisations are working together, so that everyone is working in the same direction, and all parties are benefiting.

Investing time in agreeing aims at the beginning will save time later.

Define your aims clearly and specifically. You will then be able to tell whether you have reached them.

Once aims are agreed, write them down and use them! Everything you plan should contribute towards these goals.

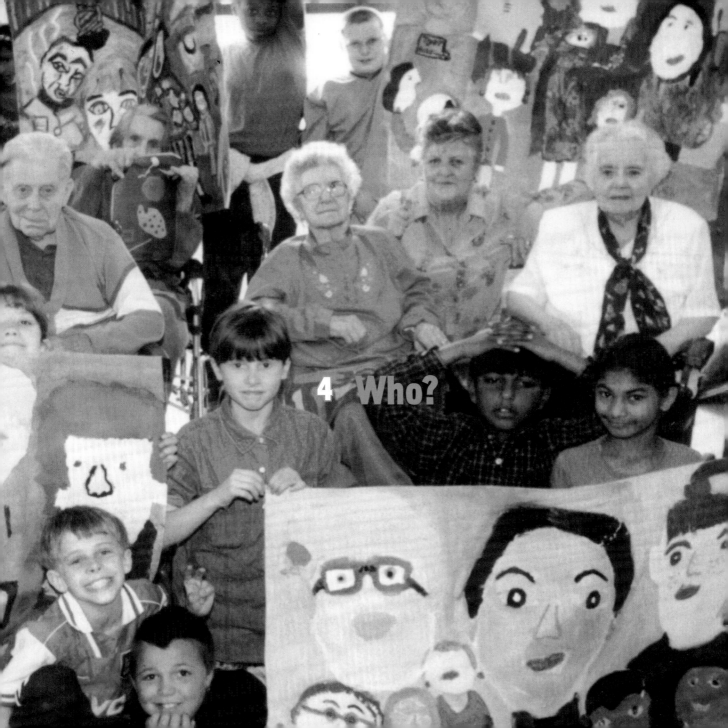

4 Who?

This section will help you consider whether you want to work with toddlers or teenagers, with an over 50's Club or much older people living in a nursing home. This will obviously have a big effect on the type of activities you plan.

Practicalities

Don't make assumptions about people because of their age. The number of birthdays someone has had does not tell you their interests, abilities, or energy level. Arrange to meet and discuss your ideas with the people with whom you might work.

Don't rely on personal experience of schools, care settings or clubs. Go and visit a school, nursing home or centre and find out about how it works.

Be like an anthropologist, studying the way in which different people lead their lives.

Don't be afraid to admit you don't know something. Ask lots of questions and listen to the answers.

How to find your group

Thinking about the detailed practicalities of your project will help to focus the research you do. If you do not know either group yet, you will have to consider the needs of both young and older people. Section 5 deals with finding artists and arts organisations. Questions to consider include:

Who are you looking for? Do you want individual older people to visit your youth group or school, or do you want a group of pupils or members to team up with a centre for older people?

Geography and distance. What's a practical journey distance for the young or older people to travel? Will it feel like visiting neighbours in the same community, or a special trip?

Timing... What's the best time of day or week for your group and organisation? Who else is likely to be available and interested then?

Seasons of the year Schools and individual young people may have exams in May and June. Festivals and religious periods, such as Christmas or Eid, mean people are busy or otherwise committed. Dark evenings and bad weather may put off people who would join a summer project.

How to start finding your partners

If you work in a youth organisation or school and want to find a group of older people to work with ask: pupils or young people, their parents or relatives, school staff (particularly those who live locally), the wider school community eg. school nurse, clergy, community organisations.

If you work with older people and want to find a partner group of children or young people ask: clients or residents, their relatives and visitors, (particularly those who live locally), staff particularly those with children, the wider community eg. visiting librarians, social workers, community groups.

Researching the local area

Once you've decided your search area then:

Look at a local map and identify likely partner venues.

Use the business phone book to check addresses for schools or care homes.

Take a walk around the local area and see who and what's there.

Contact the local council or education authority to get a list of schools, youth organisations, clubs or services for older people, such as your local Age Concern organisation.

Read your local paper to find like-minded active groups or existing initiatives who might support you eg. Health Action Zones which aim to improve the community's health within a particular geographical area.

Contacting your partners

Letter, phonecall, calling in, asking someone to introduce the idea for you... Your approach will depend on whether or not you already know this possible partner. Either way introduce yourself and your idea in a clear, positive way but let them know you are willing to discuss things and value their point of view.

If you write or phone and get no response do not be surprised or give up! This happens all the time. You may have hit a busy time, or the right person may be on holiday.

Things that may help:

Ask the receptionist for the name of the right person to talk to.

Ask when is the best time to talk to this person.

Follow up a letter with a phone call.

Leave a message that sounds as if you are offering them something so they want to find out more.

A story about motivations and priorities

Magic Me was running creative arts workshops for a group of elders with dementia and staff who worked with them. Keen to invite local children to join in, we approached two nearby schools.

One headteacher said "Our school likes to help other people in the community and the children would enjoy this. We'll call you back" ...but never returned our phone calls.

The second said " We would only do this if it's for the benefit of our pupils. It is not our job to meet the needs of older people, but the children would gain in confidence, language skills and understanding their role and responsibilities in the community. We'll call you back"

...and they did!

Meeting your potential partners for the first time

This is a chance to:

Find out more about your potential partners, their way of working, regular activities, future plans and things they want to develop.

Explain your idea so far and find out whether other people think it is practical from their point of view.

Begin to build a relationship with the key people who might work with you to plan further and actually lead the project.

Agree the next step and set a date for talking again, to keep things moving.

Hopefully everyone will be interested enough to want to develop the idea. If not ask them why. This will help you to decide whether to find other potential partners, or to change the idea. Even if everyone is very keen, do not expect to plan everything at the first meeting. People will need to think things through with colleagues before committing themselves and consider where this idea fits with other work.

Definitions of some terms which you might hear

The range within each definition is enormous. Some terms such as 'nursing home' have legal definitions, but the way of life of each home may vary greatly from neighbouring ones. Phrases like 'old people's home' may be used locally for all kinds of establishment, which actually have very different functions, residents and staff set-ups.

Older people and services for them:

Over 50's Club, Pensioners Action Group, Lunch Club Often run by members for members, these groups mainly operate in community centres or church halls, or are part of a bigger organisation eg. a health centre, Age Concern group. Some meet purely to socialise and eat lunch together, others have very varied programmes of visits, speakers and events and are keen to join in exciting local projects.

Specialist groups Older people who share an interest in any subject under the sun may meet to study, create, train, visit or to exchange specialist knowledge. Individuals or the group may be pleased to be invited to pass on expertise to younger people, but will usually be committed to a regular programme during their meeting times.

Sheltered housing This can be an estate, complex or building made up of self-contained flats, houses or bedsits, housing older single people or couples. Sheltered housing may be run by a Local Authority, charity or housing association as rented accommodation, or may be private with each flat or house owned by the occupier(s) Age, health, financial and other selection criteria may apply to new tenants though obviously people's circumstances will change over time. Some schemes have shared facilities such as meeting or function rooms which can host group activities and a 'warden' who can act as contact point, others do not.

Nursing Homes and Residential Homes These may be run by private, public or voluntary agencies. eg. private homeowners or companies; local authorities or NHS trusts; charities or specialist housing associations. Some homes are run by trade unions, ex-services or religious organisations catering for particular client groups.

Both nursing and residential homes provide: accommodation, board and lodging and 'personal care' such as help with getting up and dressing, bathing etc. Nursing homes also provide a level of medical care. Supporting residents to remain as active and fulfilled as possible is a priority in some homes and far down the list in others. Increasingly homes are employing Activities Organisers, most of whom would welcome an approach from a school or arts organisation.

Both kinds of home have to be registered, with the Local Authority (residential) or Health Authority (nursing) and they can provide contact lists for your area.*

Day Care Centre Until recently this term was not legally defined * and was applied to say a social club for very active elders with staff who provide lunch. A day care centre is for people who have been assessed as needing physical or social care they cannot get at home during the day; perhaps their family go out to work then. Transport is usually provided to and from home for the majority of clients.

* This changes in April 2002 when all day, nursing and residential care homes will be registered with a new body, the National Care Standards Commission.

Young people and services for them

You can link up with children and young people through formal and non-formal educational settings, through voluntary and statutory youth organisations, and activity or arts-based clubs. Ask your Local Education Authority for contacts in your area.

Schools and Colleges There is some variety across the UK, and between state and independent education. Schools and colleges you might find include:

Infants Schools, Junior Schools Primary Schools include Infants and Juniors. These cover the 4-11 age-range, (Years 1-6)

In some areas **Middle Schools** take children from 11-14, (Years 7-10)

Secondary Schools start at 11 years and go up to 16, (Years 7-12). Some have a sixth form for students up to 18.

Sixth Form Colleges and **Further Education (FE) Colleges** take students post-16 who are studying for A levels, Highers and GNVQs

Pupil Referral Units work with students who have been excluded from mainstream schools.

Special Needs Schools cater for students with learning disabilities, and/or physical or sensory impairments. In some areas young people with emotional and behavioural difficulties and children with disabilities are educated within mainstream schools.

Home educators are families who choose to educate their children at home. There are organisations which link these families together and they can be approached to participate in projects.

Youth organisations There are statutory and voluntary youth clubs, as well as youth groups with religious, cultural or political affiliations. You could also approach Brownies, Guides, Cubs, Scouts, Woodcraft Folk, or other similar organisations.

Arts or Activity based Clubs Some schools have after-school clubs who do dance, drama, art or music. There may also be Youth Theatres or young musicians, Saturday Clubs etc. who would enjoy being part of a project. These kind of groups will often have a structured programme which is planned quite far ahead. They generally meet outside school time, e.g. evenings, weekends and in the holidays.

Families and friends of the older people A community of older people, such as the residents of a nursing home or sheltered housing scheme may want to run activities for younger family members and friends who visit.

Selection of participants

As you and your partners become clearer about the proposed project, you will need to think in more detail about how participants will be recruited.

Practicalities

A class of 30 pupils is usually too many for an inter-generational group. 15 young participants is our recommended maximum. Choose a group of pupils which will benefit particularly or split the class into two groups which participate at different times.

Think about how the group will work, as well as the needs and contribution of individuals. For instance you may want to balance the numbers of shy people and more confident ones to get communication going.

Consider the numbers of women and men, girls and boys. School classes tend to be equally split between girls and boys, whilst elder's groups often have a large female majority. Boys may be keener to talk to men. How will you deal with this? What if you have a single sex school?

Don't be afraid to take a risk, by inviting less obvious people. Children who find school very difficult may blossom with the attention of an interested older partner. Elders not motivated to join other activities may be enthused by the different energy that young people bring to the group. Within the potential participants there may be people whom you or the venue staff (eg. teachers or activities organisers) are not clear about including. How do you decide whether to invite them or not?

If your concern relates to communication, perhaps people who have a hearing or speech impairment, who have dementia, or who speak limited or no English, you need to consider what they would need to participate and whether you can offer that. If your concern relates to acceptable behaviour in a group setting you could, together, write down some guidelines for being a participant, and look at whether the person concerned will be able to keep

within them, with appropriate support. If any of you feel during the life of the project that someone will have to be excluded, try to clarify together why this is, referring back to the group guidelines. You may want to involve other staff or other participants in the discussion.

In a school the pupils rarely choose which projects they will take part in within the school's curriculum. Talk to the teacher about who will be chosen and why. What will happen if the project doesn't work out for a pupil?

In a nursing home or day centre Individuals do have a choice, although how informed this is will vary from place to place. You may have to limit numbers because of space or the nature of the project. Talk to staff about how to interest individuals and who it would be good to invite. Talk to residents or clients about the project idea, so that they know what they are being invited to and can make a real choice.

Responsibilities to people

Working with individuals directly, rather than within structures such as schools or day centres will mean different relationships between participants and give you, as leaders, different responsibilities. For instance organisations who recruit individual older people as mentors to work with young people would usually ask for character references and check for any unsuitable police record. The same might be true of young people volunteering to work with vulnerable older people. Schools, youth centres etc. will have their own protocol and procedures, to which you should refer.

Principles of selection

Be clear why each person is being invited or not.

Ensure participants or staff have enough information to make choices but be aware of how much choice they actually have.

Look beyond the obvious and the people who always take part.

The people selected do not already have to 'be good' at the activity.

Be alert. Institutions may want to put on 'a good show' for the outside world rather than offer a new opportunity to a less able child or elder.

Select the right number of people for the chosen activity and space.

Decide at the beginning whether you are open to new people joining the group during the life of the project.

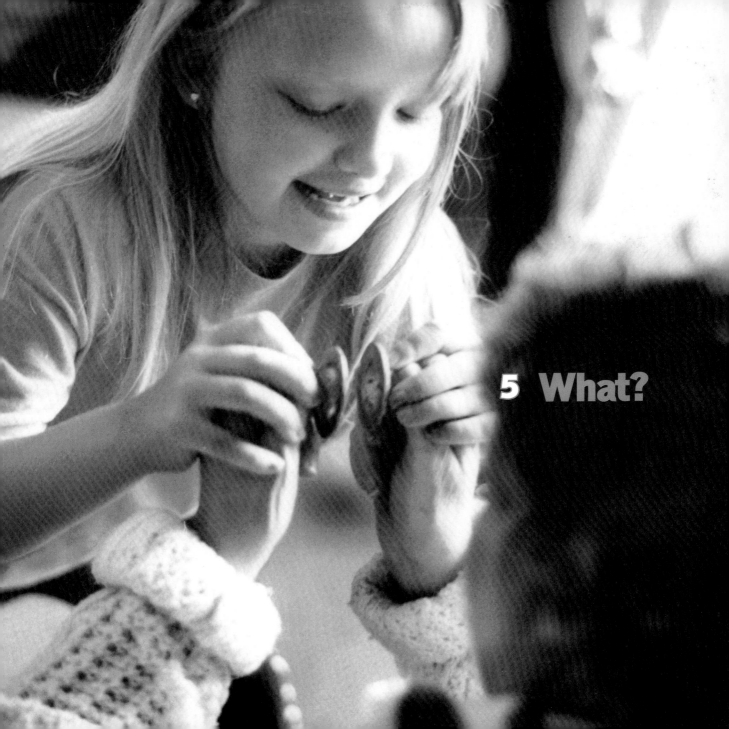

5 What?

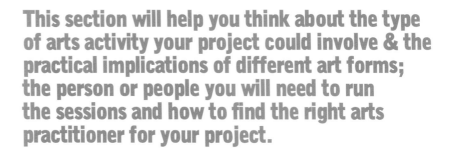

This section will help you think about the type of arts activity your project could involve & the practical implications of different art forms; the person or people you will need to run the sessions and how to find the right arts practitioner for your project.

Most Magic Me projects focus on one or more art forms. We find that the arts create an ideal meeting ground for the individuals involved. They give people the chance to be creative, to have fun, to learn new skills, and to pass on experience. The diversity of the life experiences of the participants adds a great richness to the arts work. All the participants can have an equal place if the activities are carefully prepared. Different art forms create a different dynamic, and they all have varied practical implications, so it is important to choose the most appropriate activity.

In some situations the initial idea for the project is bound up with a particular activity. For example, you may work in a school where the students want to create some drama work in partnership with local older people. But it might also happen that you want to bring two groups together, but you don't know what kind of activity would be best to help build that relationship. Sometimes there is a clear theme or topic to follow - perhaps something which the school students are studying, or something linked to a special event, a festival or celebration.

Choosing the right activities for your project

You may not realise quite how wide the range of options is. Here are some examples, and you may well be able to add more. The categories overlap.

Craft, Design & Visual Arts Sculpture, Weaving, Mask making, Printing, Paper making, Graffiti, Photography, Digital imaging, Video, Collage, Patchwork, Plasticine, Posters, Body paints, Painting, Ceramics, Mosaic, Costume and Hat making, Puppets, Silk painting, Installations, Animation.

Written & Spoken Arts Poetry, Plays, Raps, Lyrics, Stories, Speeches, Memories, Operas, Word games.

Performing Arts Drama, Singing, Puppetry, Mime, Video, Opera, Mask, Comedy, Percussion, Circus, Carnival, Ballet, Contemporary Dance, National and Folk Dance, Ballroom Dance, Choir, Band, Orchestra, Theatre, Radio, Verbatim.

Domestic & Celebratory Arts Garden Design, Sewing, Patchwork, Celebrating Festivals, Cooking, Making Cards and Decorations.

Visual Arts

If you are working towards a finished product, can it realistically be completed in the time? Visual arts activities work well for pair or group work. The process is important, and contains a lot of opportunities for contact and for learning. There is usually a product, which people can keep, (eg. a sketch, a model, a mask, a poster, a photo). Forms which use technology, (eg. animation, digital imaging), can be very exciting for participants who have never worked in these media before. While people are working they can easily talk with one another. Some individuals will get anxious about whether their work is 'good enough' and some will find it hard to experiment.

Spoken and Written Arts

How could this work be best shared with others? Could you use media other than pen and paper, (ie. an overhead projector, a flip chart, collage)? Are there issues of literacy in the group?

Spoken & written arts work well for individual, pair or group work. There can be lots of discussion as well as the creating of poems, stories etc. and you can use drama, art work, dance and reminiscence to stimulate ideas. The differences in vocabulary and usage among the participants can be celebrated, as can multi-lingual skills. Choosing what to write or to say can help people distil their ideas, and perhaps get out of the rut of their habitual ways of speaking, writing or telling stories. People can find it quite hard to start writing work - the blank page can be scary! So it's useful to have games and fun activities which relax everyone and warm them up. Children and young people sometimes associate writing with school work, so be careful how you present it.

Performing Arts

If you are working towards a finished product, who might your audience be? Where will the work be shown? If you are using film or video, who will be involved in the editing?

A lot of performing arts work is very good for building relationships within a group, and for helping people learn to work together. Equally, it can feel a bit exposing, so it needs to be presented in a way which helps people to feel safe and valued. It can demand quite a lot of focus and concentration, but it also gives people opportunities to enjoy and extend themselves. When the work you do is based on the experiences of the participants themselves, people often feel very valued when they see their own story played out. Different performing art forms work very well together. Working towards a performance or video can provide a variety of opportunities: to act, dance, sing or play an instrument; to create costumes or decor; to film and to edit; to direct.

Domestic and Celebratory Arts

What could the young and older participants have to teach one another? Do people have skills which they might consider to be ordinary, but which could become special when shared in a project?

A story about dancing with words

We spent a term creating poetry around the theme of 'Celebrations', which worked well for the younger and the older writers. To help stimulate ideas we used a lot of different approaches: we worked with a dancer, and thinking about and trying out lots of different dances provoked memories and feelings which we wrote down straight away. One day we all sat around some lit candles, and thought of all the words we associated with them, from birthdays to restaurant meals and religious festivals. People enjoyed being able to use 'ordinary' words in poems, but also loved discovering new ways of expressing things.

A story about building on a simple idea

Discussing the content of the video we found that all the participants wanted to do songs from the Music Hall. The older people taught the young people some favourite songs and we put the songs into scenes. The group who did 'Daisy, Daisy', did it dressed for a wedding. This sparked discussions about falling in love, arranged marriages, toy boys, and marrying for money and more scenes were devised. People who didn't want to perform in the scenes were interviewed by the actors about love and marriage. We learned lots of skills and we laughed a lot.

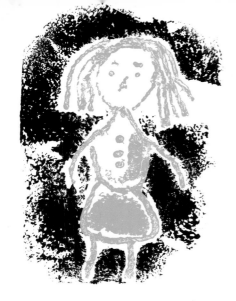

People can feel really valued when given the opportunity to share skills which they don't always think of as skills. People living in a residential home may no longer have the opportunity to cut up fruit and vegetables, to make a cake or to sew or garden. Working together on practical tasks gives everyone opportunity to talk, and can provoke stories of memories and experiences. Preparing for celebrations gives people opportunities to share their background and culture, to talk about values and identity, and to enjoy special times together.

Process and Product

There can be a tension between a focus on the process, and a focus on the end product. Here are some of the pros and cons.

The *benefits* of working towards a product, (ie a performance, an exhibition, a book) include:

> Participants enjoy working towards something. It creates a dynamic in the project which can get people through difficult patches.
>
> It unites the group in a common purpose.
>
> People feel valued when their work is appreciated by others.
>
> People often achieve more than they imagined they could.
>
> Preparing for an end product helps people to learn to be a critic, to edit, to select the best of what they have all done.
>
> A final celebration of the work, and a lasting legacy of it, can help with the process of ending the project.

The *disadvantages* include:

> Pressure of deadlines can detract from the pleasure of the process.
>
> Participants' anxieties about being good enough may get worse.
>
> Leaders may have to take over in the final stages, if the group does not have the capacity to do the final finishing touches, (i.e. editing a video)

The *benefits* of working without a finished product in mind include:

> Without a deadline the project can be very responsive to the needs of the participants.
>
> It is easier to integrate suggestions from the participants if you have no product brief to fulfil.

The *disadvantages* include:

> A lack of dynamic in the project. Participants can lose their sense of why they should come back next week.
>
> It can be harder for schools to justify participating if there is no clear agenda.
>
> It can be difficult to explain or define the project when inviting people to join in.
>
> Leaders can find it hard to keep up the momentum.

A story about enjoying things you're good at

In a project which linked a group of Primary School children and a group of Asian elders, we were preparing for a puppet play. There had been a lot of discussion about the story for the play, but the real excitement came when we started making the costumes. There were considerable sewing skills among the women, and some great discussions took place between all the participants about exactly what all the characters should wear. Everyone liked talking about clothes. Each week people were bringing in materials, and sometimes taking things home to finish. On the day of the performance we ate food prepared by elders and children, and the event finished with a group of the men ceremonially planting a bed of coriander in the Day Centre's garden.

Who is going to lead the sessions?

Here are the skills and qualities which are really valuable to have in a project leader. You may not find them all in one person, but it is often beneficial to have a project led by more than one person. This may mean a team of artists working together, or an artist working with a teacher or a care assistant or activities manager.

Ideally, between them, your leaders should have:

a real enjoyment of their art form, and ability to enthuse others

experience in the art form and a flexible approach to sharing it

the ability to use other arts forms where appropriate

experience of working with older people, and/or younger people

experience of working with groups

ability to work in a team

experience working with institutions like youth or day centres

patience, stamina and tenacity

a real interest in the personal/social development of participants

organisational and creative thinking skills

appropriate specialist knowledge of target group

where appropriate, the ability to work in more than one language

curiosity and good observation skills

self awareness and the ability to deal with unforeseen circumstances.

When looking for an artist or arts organisation to work with you could approach local arts organisations and find out what they have to offer. Your local council's Arts Officer may have a register of arts practitioners or can put you in touch with other organisations who can help. Advertise, or put up notices in places where you think local artists might go. Ask other people or organisations if they would recommend anyone. When you do find a person or an organisation it is worth finding out about other projects which they have done. Ask them to show you examples of their work, and if possible, talk to others with whom they have worked. If you are going to employ an artist directly you will need to interview a range of people and get references.

Principles

Think about what will work best for the group in the context you have.

Don't be too ambitious in the scale of your project if it's your first one.

Ask lots of questions to make sure you have all the information you need.

Find good leadership.

Don't compromise on high quality arts input.

Don't underestimate the participants.

A story about scale

A Holiday Club provided an opportunity for a group of young teenagers to continue contact with their partner group from a school project. The Club took place in the lounge of the Day Centre, during half term.

Our theme was 'a tropical island', and over three days we created a palm tree, a rock pool and waterfall, butterflies and gorgeous flowers, and a volcano, using card, tissue paper, newspaper, paints, wire and glitter. One of the adults didn't participate much at first, but watched and gave odd bits of advice. However, when the volcano needed painting, he was soon on his feet with a large decorator's brush. This was a scale of activity he felt comfortable with.

Others too found the kind of activity they wanted. Some cut out tiny petals, and painstakingly created garlands. One young woman and her adult partner spent three days creating a parrot. The room was completely transformed, and we celebrated the ending of the project by making a huge fruit punch together and dancing to suitably tropical music. The Day Centre kept the art work up for the rest of the week so that others could enjoy it.

6 Where?

This section will help you think about how the place chosen for activities will affect people's involvement. The choice of spaces available to you may be very limited, but try to choose one that is the most appropriate for the majority of potential participants.

Things people need whatever you're doing:

 a good temperature and fresh air
 enough space for the activity, but not too big so you feel lost
 toilets for everyone nearby
 easy access
 cups of tea and drinking water
 a private space
 no interruptions or distractions

Practical things that help people join in:

 sitting next to the right person (maybe a peer or a staff member)
 being introduced to people, each time if needed
 accessible room, not associated with medical procedures
 a light, happy, bright, welcoming room so it feels like an art room
 room to move around for different activities
 choice of different chairs: with and without arms, different heights
 variety of round and square tables for different activities
 feeling free to make a mess!

Things that interrupt or distract people:

 ringing telephones
 being thirsty
 being too hot, or cold, or in a draught
 people walking in
 worrying if the transport will arrive to take you home
 not bringing the right glasses
 hearing aids that are not set correctly
 noise from other people (eg. kitchen) or outside

a doctor wanting to see a patient
medicines being handed out
wanting a foot rest, cushion, tissue
worrying if there is a toilet near by
worrying about getting back for a visitor
worrying about other work that is building up
having the television or radio on
someone shouting in another room
decorators painting the corridor...

Lists compiled by a group including participants, nurses, occupational thera-
pists and artists taking part in weekly arts workshops for patients at Mile
End Hospital.

Your place or mine?

If you are bringing together two established groups, who should host the first
meeting and who be the visitors? Consider the atmosphere, the route from the
front door to the room you will use, other people who use the building at the
same time. If you work in the venue, try and see it through stranger's eyes.

Will travelling to a different place mean that some potential participants are
excluded because they won't have the energy, are already nervous of the idea
or need support which it will be impossible to provide at every meeting? How
easy is the journey for the visitors and is travelling time an issue?

In the majority of Magic Me projects young people visit the older people
because it is quicker and easier for them to move around and because many
schools are still not fully accessible for disabled people, which would exclude
many of our regular participants. Even so, participants usually welcome a one
off visit to the school, at some point during the project, for which extra time
and staff can be arranged.

The right space

Different art forms require different types and sizes of space. For instance
have you got a room where it's alright to make a mess with paint, clay,
wood? Do you need access to running water or easily washable surfaces? At
one nursing home the hairdressing 'salon' was only used on Wednesdays. On
Thursdays it became the Magic Me silk screen printing workshop.

Have you got enough space to do dance, drama or music? Are you able to
make a lot of noise if you need to, without disturbing people? Is the floor
suitable for dancing? Is it possible to black out the room to show slides? Or do
you need a quite space, where people can concentrate on writing undisturbed?
Do fire and safety regulations mean using certain materials or frames when
displaying art-work long term? Check these details with someone who knows,
as soon as you can.

You may also need a secure cupboard or room to store equipment and materials and possibly a growing amount of art works, costumes or models as the project progresses. Sometimes things need to dry or grow or hang between sessions. Space is at a premium in many institutions so negotiate this early on too. Nursing home residents participating in one photography project were pleased to be able to store tripods, backdrops and props in their rooms between sessions, when they realised the tutors were carrying these back and forth from home each week.

Arts venues and age neutral places

Sometimes a venue new to everyone is appropriate, for instance a community centre or the home of an arts organisation which is involved. Participants may be stimulated to join future events at these venues if the project goes well. They may feel part of a wider community and relish getting away from being labelled 'young' or 'old' by the venues they attend. One 76 year old man invited to a Magic Me project via his Social Worker had refused every other activity offered, because they were 'all for old people' A former youth worker, he chose to join, and became a key member of an inter-generational group who met in a local community centre for a photography / design / digital imaging project.

Stimulating environments

A group outing can provide stimulus for many project sessions and is a shared experience on which to build. Examples include: a tour of an art gallery with a specialist guide; drama sessions in a National Trust property as part of a theatre project about Home; a photography workshop in a burger bar. People may also enjoy meeting with another group to exchange ideas and experiences, share their work with one another, or take part in a bigger initiative such as a festival as artists or audience.

Principles

Do not underestimate the effect of the space on what you do.

Make every effort to get the best possible space.

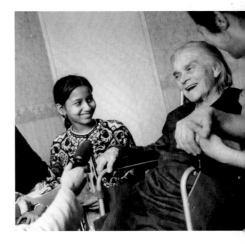

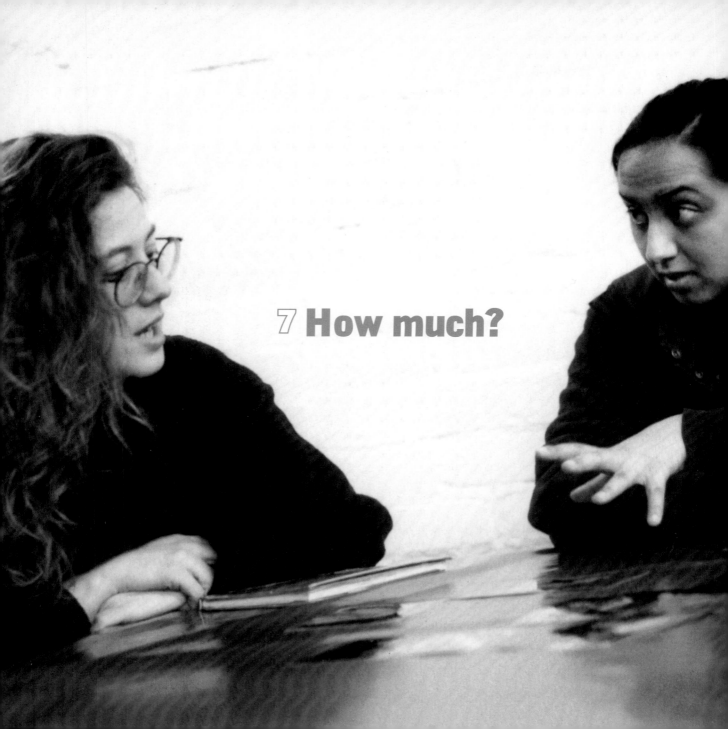

7 How much?

This section will help you to assess how much your project might cost, and to consider ways of getting funding for this kind of work.

Practicalities

When you prepare the budget, try to include everything that might cost money, so that you don't get caught out later on without adequate resources.

Don't guess what things cost. It really pays to research the costs properly.

When you are collaborating with other organisations, try to be very clear about who is paying for what, who is providing what.

A shopping list...

Here is a list of things you may need to put in to your budget. Add or delete according to your project.

1. Artist's Fees The fee for your arts practitioner should be based on the number of working days in the project, plus preparation time, time for meetings with colleagues, time for evaluation and possibly extra work on the end product. For a two-hour session they would need at least half an hour to set up and half an hour to clear up. In addition they would need time each week to prepare the session. Most arts practitioners are freelance and will be paid a fee, based on a daily or hourly rate. If you are unsure of what sort of fee to offer, check with an arts organisation, or with the Arts Council.

2. Materials The arts practitioner will know exactly what is needed. Don't forget the basics: sellotape, scissors, Blu-Tack etc.

3. Travel expenses These may be payable to an artist or other project leader. You may need transport for one of the groups to come to the sessions.

4. Equipment eg. Tape/CD players, Video equipment, cameras. You may be able to borrow these, but make sure they are available for all the sessions for which you require them, that they work, and that they have batteries/mains supply etc.

5. Trips Your project may include trips out for the participants. You may need travel costs, admission costs, parking costs.

6. Refreshments The host group may be able to provide these, but they may appreciate a contribution towards the cost. You may want something special for the final session.

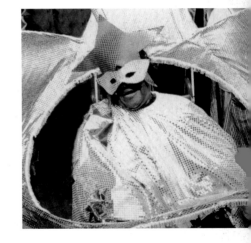

7. Final Event Additional costs may include mounting/displaying art work, production costs, space hire, publicity.

8. Room Hire You may be able to use space for free, but might be asked to pay a contribution towards lighting and heating.

9. Supply Cover If a teacher is coming to the sessions with only half the class, the school may have to pay another teacher to work with the rest of the pupils.

10. Insurance Check whether additional insurance is required to cover any trips, or when groups visit each others' buildings. You may also need to insure equipment used.

11. Administration Include phone calls, postage, photocopying, faxing, producing a report.

12. Volunteers If you involve volunteers you may need to offer them travel and refreshment expenses.

13. Documentation Include taking photos of the sessions, or videoing some of them. This might also cover writing up the project.

14. Contingency Add a minimum of 5% to the total budget to cover any unexpected expenditure.

Raising the finance to meet your budget

It is always good to start by looking at what you have already got. Some schools, day centres and residential homes have a budget for arts projects. In some centres and homes there is an established pattern of adults paying a contribution towards trips out, or art materials. In some schools students' parents may contribute towards special projects. The organisations involved in the project may be able to offer some elements of the project for no cost.

If you need to apply for funding explore grant-making trusts and charities who have funds for the arts, for education, for older people, and for young people. Some organisations have a particular commitment to funding projects in a certain geographical area. Almost always, the body which is applying for the funding will need to have charitable status.

Most local councils have an Arts Officer. Approach them to see if they have any funds that would be relevant to your project, or know of other sources. Your Regional Arts Board may also have schemes under which you can apply for funding. Applying for funding can be time-consuming, but most funding bodies are happy to offer help and advice, as it is in their interests to have clear and concise applications.

Principles

Don't leave the financial side until last.

Huge budgets don't guarantee successful projects.

Underestimating costs will create a strain on the project leaders.

Few arts projects end with a surplus.

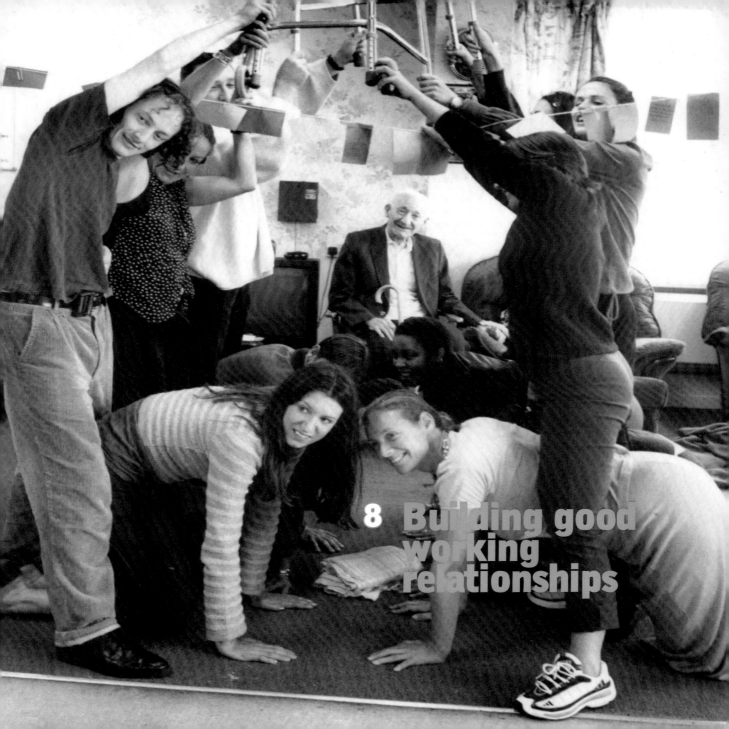

8 Building good working relationships

This section will help you think about how to set up sustainable ways of working with other organisations, share the workload and responsibilities of the project and be realistic about the challenges and benefits of cross-sector work.

As you piece together the plan for your project you will need to get to know and negotiate with people at all levels within the other participating organisations.

Practicalities

'Partnership' means different things to different people. Clarify with your partners what you all expect from one another.

Agreeing shared aims for the project is a good way to ensure everyone is working in the same direction.

Working with other organisations can hold up a mirror to your own workplace. You may discover things about yourself that are unexpected, or reveal weaknesses. Try not to get defensive: be prepared to change the way that you do things and to learn from other points of view.

Ensure that the people who will lead the practical work are involved in the planning as early as possible. Acknowledge and draw on their expertise and experience.

Each organisation needs to identify all of the people who may be affected, or who may have an affect on the project and take responsibility for consulting, informing or negotiating with them as appropriate.

Don't let practical arrangements or difficulties dominate the relationship, at the expense of creative thinking and discovering new ways of doing things.

How often do you need to meet once the project is underway? Too many meetings can mean wasted time and waning attendance. Key people should meet to monitor progress, support developments and liaise with managers.

The vital role of managers

It is our experience that the active interest of managers is vital to the success of inter-generational projects. Headteachers and managers of older peoples' or arts organisations need to understand the nature of the project being proposed and the implications if they decide to take part. They will have to agree to and organise any changes that will be needed in the usual pattern of staff's work or use of budgets or rooms.

Principles

Don't assume that people are good at working in partnership, especially across sectors. Understanding and relationships will take time to build.

Don't expect people to be psychic. Something that is crucial to you or part of your everyday life may not have occurred to them.

Money can be a powerful dynamic in any relationship. Be aware of this when partners bring different resources to a project.

Don't assume you understand one another's definitions and terms.

Do you know what any of these terms mean and what their implications are?

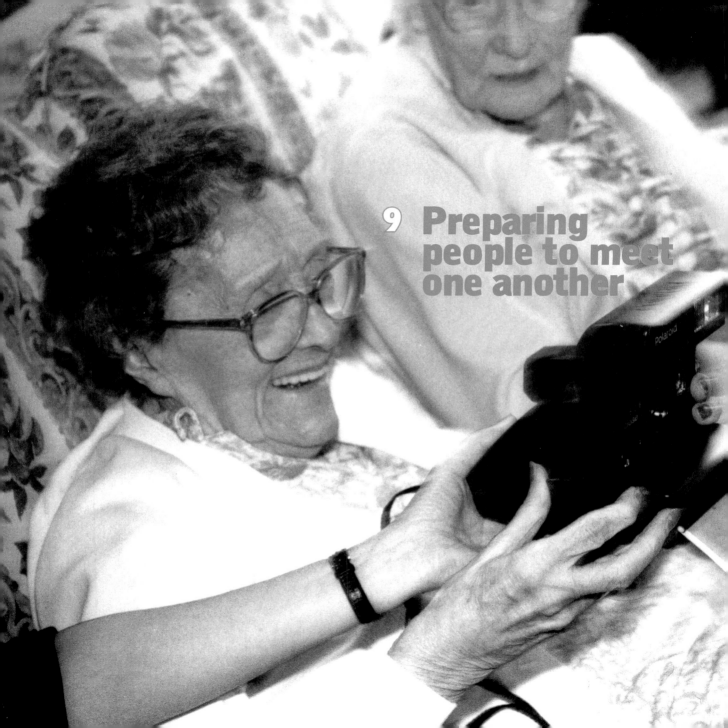

9 **Preparing people to meet one another**

This section will help you to identify the key areas of preparation, consider how to prepare with all the different people involved and explore some ideas for preparation.

Before the young and older people come together, it is vital they have time to prepare themselves. Staff and other people who will support the groups also need to be clear about what they will be doing. Time spent now on preparation will bring benefits later. A discussion or activity with each group separately will also allow you as the leader to get to know people and prepare you to work with them on the rest of the project.

During preparation participants need to:

be able to ask questions
be able to express concerns and worries
find out what they need to know to start the project
be able to contribute ideas, suggestions and expertise
get ready to meet and work with their partners
begin to build relationships with the people leading the sessions
be prepared for any particular aspects of this project e.g. thinking about the topic or theme or considering how to meet people with a very different lifestyle or culture.

Practicalities

All the participants will need some preparation. This means anyone involved in the project: arts practitioners, young and older people, and all staff including classroom assistants or care assistants and volunteers.

People who will be leading the activities need to lead the preparation too.

Preparation should not be seen as an optional part of the project. It needs to be given status, time and the right room.

Particular information may best come from an 'expert' e.g. staff from the nursing home might explain dementia to a group of children, or a teacher might answer elders' questions about the school and its pupils.

Remember that you are likely to have one group who are the 'hosts', and another group who are the 'guests'. This may affect how they are thinking about the project.

Check with the host organisations any protocol or cultural expectations that you need to take into account. For example in a day centre for Moslem elders, will you need to talk separately with the men and women and will both groups be happy to shake hands with you as a man, or woman? In a school, what should you call the teacher in front of their pupils?

Allow space in preparation sessions for questions, as this will often give a good indication of what the group want and need, and what their main interests are. This is a good chance to establish the real level of interest of participants. In day centres and residential homes people may have volunteered, but they may not be very clear about what they are coming to. They may want the opportunity to opt out at this stage. (Schools and other institutions may find this less appropriate as the participants don't usually volunteer.)

How do you say...?

People may feel anxious about terminology. Teachers often ask, "Do we call them pensioners, elderly people, elders or....?" There can be difficulties with use of language in areas such as ageing, death, disability, ethnicity, physical or mental health. Helping people to find the right words to use will enable them to relax and start talking, and to do this you may need to do some research yourselves. Find out how people like to be described, clarify specific terms such as dementia or Alzheimer's disease, and think about how you might tactfully challenge use of words which others might find offensive.

The preparation session can be a kind of 'taster' for the main project. So it is worth thinking about how to make it enjoyable as well as informative, how to make it catch the group's interest and enthusiasm.

Some activities to use with children or young people

List of ten Ask children to write a list of 10 words that describe older people. Use the material generated to start a discussion. Are all older people like that? Does anyone know someone different? Think about where older people live. Only 4% live in a nursing or residential home. What about people they know? Characters on television soaps? The Queen Mother? Start to break down stereotypes.

How to introduce yourself For children and young people meeting strangers, especially adults, can be very hard. They need to practice, to get over their giggles on their own and to feel safer.

What do you say after "Hello, my name is ..."? Work it out. Discuss topics that it is okay to talk about and those that are private. List questions that pupils could use and practice asking them. Remember conversation is a two way thing: you need to offer information as well as ask for it.

Shaking hands If it will be appropriate, ask pupils to shake hands with elders when they arrive and introduce themselves. This means that they have to get close enough to say hello and talk directly to one person. Seemingly frail elders can have a strong grip that surprises the young people and helps them be less afraid of asking the elders to participate. A slightly formal start reassures the elders that the young people are polite and well briefed.

Discussion points What do you do if someone can't see and doesn't know you're offering your hand? What if someone can't use their right hand? What if someone doesn't let go? Help children anticipate embarrassing or difficult moments and they will cope better if these happen. They will also not feel so responsible for difficulties, not of their making, if you have mentioned these as possibilities beforehand.

Some activities to use with older participants, staff or other adults

List of ten Ask adults to write 10 words that describe children, or teenagers. Use the material generated to start a discussion. Are all teenagers or children like that? Does anyone know someone different? Start to break down stereotypes.

Themes and topics Children are used, in school, to focusing on a set subject. Adults who live together or meet for other reasons, may not be used to group discussions or learning together. Introduce informal but structured ways of working that you will use during the project to discover participants' existing knowledge and interests to do with the project themes. Bringing in pictures or objects which relate to the theme can help people to share ideas and memories.

Hands-on Use some of the arts activities which you will use in the sessions to get the group working with one another. They may have very clear ideas about music or dance or drama or art, depending on their experience, and it can be useful to give them some experience of what you might be doing early on. But it also helps to set the tone for the project; that it will be about everyone participating.

Some activities to use with people of all ages, including staff, relatives, volunteers

Draw a personal family tree This can be a drawing of a tree with people on the branches. It can include not just family but friends, anyone who is important in your life. People will learn more about themselves and their peers, consider differences between individuals in their peer group and think about issues of confidentiality and what kind of personal information it feels comfortable to share with a group.

Get the picture? The adults take photos of one another and send them to the children, who return the favour. Names or other information can be added by the people in the pictures, or the leaders may provide this verbally. By looking at and discussing the photos people can air their feelings about one another before they meet. A group of elders may need to anticipate meeting a group of adolescents, with space to consider their feelings or ask questions. Young people may need to be shown and practice particular skills if meeting elders who have had strokes, or have speech or hearing impairments.

The leaders can introduce the participants to one another as individuals, rather than just the children or the adults and they can prepare more specifically.

A story from the Isle of Dogs

Staff at a day centre for older people had agreed to a visit by a group of 13 year old school pupils, researching a project on the Blitz in the London Docks, as part of their history curriculum. One lady was well known locally for her store of vivid memories of Island life and staff were surprised when she said she did not want to meet the pupils.

In private conversation with the lady the Manager discovered why. "I was always a dunce at school," she said. "I can't remember dates and the children who talk to me will get really low marks and get in to trouble because I'll tell them all wrong."

Once reassured that pupils were looking for real life experiences and individual stories, to back up the facts and statistics in their text books, the lady was happy to take part. An excellent story teller, her contribution was much appreciated by the pupils and she was pleased to have been able to help them.

Creating a contract

A contract written and agreed by the young people, or by all the participants, means that codes of behaviour are discussed from the start and suit the situation. Anyone who then breaks the code will have to take responsibility for their actions and answer to the group. The onus is not always on the project leader or the teacher to 'police' behaviour. It's better not to bring in a contract from outside, but see first what all the people involved feel is important. You can always make changes later to reflect developments in the project.

Sample contract

From a project involving a group of 14 year olds and residents of a Nursing Home:

We the undersigned agree that during the Magic Me project we will:

Join all parts of the project:
visits to Tall Trees Nursing Home
preparation and follow-up in school
keeping a weekly project diary

At Tall Trees we will:
remember we are guests in someone's home
keep the noise level appropriate
address residents as 'Mr' or 'Mrs' unless given permission to use their first name
obey the instructions of Tall Trees residents and staff

At all times we will:
listen to other people's ideas
encourage other members of the group
respect other group members by not discussing their private business outside the Magic Me group.

Signed by

......................................

all pupils, artists and teachers

A story from Bethnal Green about prejudgements

A group of users at a Day Centre for older people was discussing whether to accept an invitation to join a ten week arts project with pupils from a Junior School across the road. Two or three of the adults were adamant that children were far too unruly and destructive these days to be allowed into the Centre. They should be with their teacher, and the school shouldn't be asking pensioners to do their work for them. The artist who had come to talk to the group about the project noticed that many of the group had not spoken. She asked directly, "Does everyone agree?"

After a short silence one man spoke up, and said that as a boy he had always been in trouble at school, and that he thought it would liven things up if the children came. A very lively discussion ensued, and the group decided to give the children a chance. Rules were agreed on, relating to where the children could go in the Centre, and a room was set aside for members who did not want to participate.

Preparation for the arts practitioners

Many of the practical preparations are covered elsewhere. An aspect which it is important to consider is your own emotional readiness for the work. In some circumstances working with older people can have a strong impact, reminding us of our own mortality, the losses which ageing can bring. Something which happens within a session, or an encounter with a particular person may bring up feelings which relate to your own situation, and that of your own family.

When you work with people who respond very little, or in unusual ways, for instance people with dementia, you may feel challenged, personally and professionally. You may feel ambivalent about the institutions in which you will find yourself working, and critical of the system itself. The adults in the project may also have mixed feelings about the situation in which they find themselves.

The younger people will look to you for support in relation to their feelings about ageing, or institutions and how they work. They too will bring their own challenges. Involvement in a project which brings them out of school or their usual setting or routine can affect behaviour in different ways. There can be a freedom in the sessions which some young people find hard to cope with at first. Their emotional needs are likely to surface more and more as the project progresses, and they may turn to you rather than their teacher.

As an outsider, participants and staff will often want to use you as a sounding board, a source of information, a go-between or an ear to complain to. You will have to judge how appropriate this is, and how essential to the well-being of the whole project. Be careful not to take on more than you can reasonably do, and try not to offer things which you can't deliver. Know your boundaries, and make sure that you have organised support systems for yourself.

Principles

Create a safe place in which people can air their prejudices and their knowledge or experience.

Start where people are, without making assumptions about their knowledge, experience or feelings.

Help people imagine what the project will be like and what they'll be expected to do.

Bring them to a point where they are ready to take part in the first joint project session.

Doris would like to meet the queen

IF Doris had a pet it would be a pony

Doris favourite music is jazz

Doris favourite food was pie and mash

Doris favourite colours were blue and yellow

Doris is 81 years old

Doris second job was a lift attendant

Doris has one daughter

Doris first job was an office cleaner

Doris liked school

When Doris went to school she was hurt once

When she was a child she visited Southend because she liked it

When she was a child she lived in Bethnal green

Doris was born in London in 1915

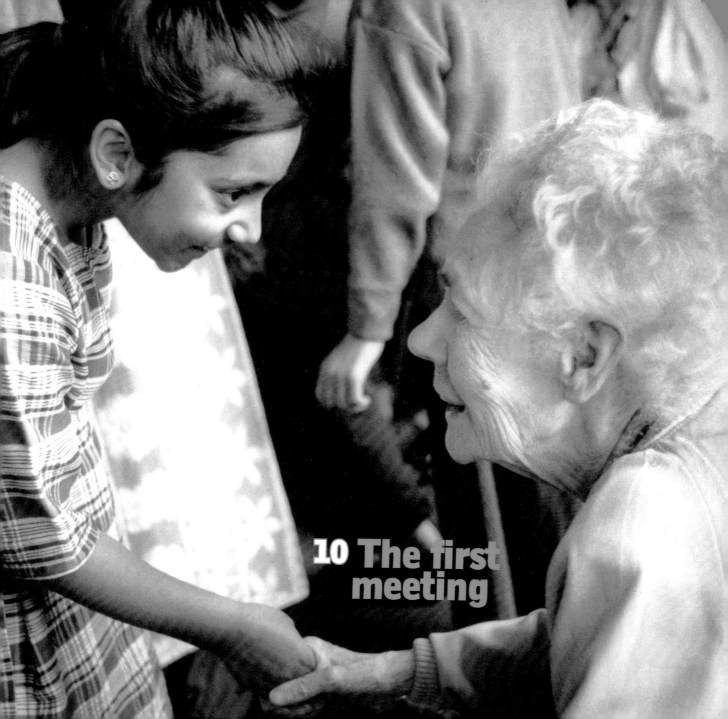

10 The first meeting

When they first meet the participants may feel apprehensive, excited or unsure. This section will help you to ensure that this session will create a good foundation for the rest of the project.

At the first meeting people need to:

understand what they are being asked to do

feel comfortable, both physically, and with what they are asked to do

know why they are there and what's happening next

By the end of a session people should:

feel recognized by at least one other person

know when and where they will be meeting again

have some sense of what will be happening the next time they meet

Practicalities

Practical problems can often hamper the smooth running of a session, and you want to make sure that everything works towards good communication and an enjoyable time for all concerned. Here are some of the things you may need to think about in advance:

Who is going to prepare the room where the session will take place?

Do you need to negotiate with anyone using the room before or after you?

If materials need to be got ready in advance who will do that?

How do the host group get to the room? Do they need support?

How do the visiting group get to the place where the session will take place?

Who will greet the visitors when they arrive? Is it important that they are introduced to key staff members?

Should visitors see more of the building than just the room where the session will take place?

How can you ensure that there is room for the visitors when they arrive? (eg. that the host group are not sitting in a tight circle with no spaces).

If you plan to have refreshments during the session, who will organize that?

At the end of the session, who will clear up?

A story about saying hello

The ten pupils chosen for the Magic Me project were excited as they left the school gates for their first visit to the nearby nursing home. As we entered the grounds, the three storey building towered above the ten year olds, and they approached the front door quietly. One child rang the bell, and silence fell as the front door opened. The Activities Organizer greeted us, and led us upstairs, accompanied by the noise of nervous giggles and whispered questions. The nosy ones led the way, but as we arrived at the lounge, even the bravest children stopped at the doorway. Ten residents looked up expectantly from their circle of chairs. Somehow we had to walk in and find the courage to say "Hello".

At the end of the session the children walked around the circle, saying goodbye to each resident in turn and shaking each hand. The room seemed a more relaxed place. Residents chatted with one another about the children and how clever they were. Two boys eagerly took a bag of toffees one man gave them to share out at school. An hour had gone quickly and we were already looking forward to next week's visit.

The practical aspects can feel overwhelming, and it is important to remember that the focus of all this work is to facilitate a meeting between the participants which they will enjoy.

Some activities to use working in pairs

Name badges A young and an older person work as a pair, making and decorating name badges for one another. It can be very useful to have name badges to look at, as people learn each other's names, but the activity also gives the pair a chance to get to know one person a little. In some projects there will be names which are unfamiliar or difficult for others. Seeing them clearly written down can help to ease this.

Spelling out initials Find out your partner's name. Take it in turns to create, with your hands, arms or whole bodies the shape of the first letter of each of your names. See if the others can read it and guess the name.

Drawing around hands Place your partner's hand flat on a piece of paper, and draw carefully around it. (Lean the paper on a clipboard or the table)

Sometimes both partners can do this for each other, sometimes one person will have to do them both, for example when one person's hand is too weak to draw. You can then ask each other questions, and fill in the drawing of your partner's hand with their answers. Your questions may be about facts: name, age, where you live etc. and about likes and dislikes, beliefs, hopes and dreams. The hand-drawing becomes a kind of portrait. Materials: Clipboards, paper, pencils and felt-tip pens.

Drawing portraits If people sit and draw one another this can lead to silent concentration, but it won't really break the ice and can feel very uncomfortable. Ask people to draw portraits which show their partner in another situation eg. "The best day out I ever had was when..." "If I could go anywhere in the world I would go to..." "One of the best things I ever wore was / is" Then the pairs have to talk to find the details of colours, buttons, the occasion etc. Drawing can be nerve-wracking at first, especially people and getting likenesses. Try mixing photos or photocopies (of photos) of the people and drawing or painting the new clothes, or the scene around the figure. Materials: Clipboards, papers, pencils, crayons or paint etc.

Some activities to use working as a group

Pass the squeeze Sitting or standing in a circle, the participants hold hands. A designated person squeezes the hand of their neighbour on one side, who passes it on to her neighbour, so that the squeeze travels around the circle. The leader can also test people's concentration by sending two squeezes, one in each direction, at the same time.

Ring on a string One person is chosen to be 'it' and the group sit or stand in a circle around them. The participants all hold on to a large loop of string or ribbon, onto which has been threaded a ring. A curtain ring will do. The ring is passed around from hand to hand, but the object of

the game is to make it hard to see who has it. At a given signal, everyone keeps their hands still and 'it' tries to guess where the ring is. Materials: String or ribbon, ring.

Balloon A large balloon can easily be passed from person to person, around or across the circle. This can be combined with a name game, starting perhaps with each one saying their own name as they throw the balloon, and then, as names are learned, calling out the name of the person to whom they are throwing it. If you put some dry lentils into the balloon it is heavier, and slower, and can be easier to handle. Materials: balloons, lentils.

Make a time line Give all the participants oblongs of paper on which they write a year and either a key historical date, or a personally significant date, such as the year and date of their birth or marriage, their arrival in this country or the start of school. Rather than ask everyone to fill in their own, get participants to interview each other to find the dates. As you go along, these can be hung up on a line, or stuck up on the wall, chronologically, creating a time-line which interweaves world and personal events, but which also begins to tell the participant's stories. The information revealed can lead into many other activities. Materials: Paper, cut into oblongs, pens, washing line & pegs or Blu-tak.

What's my line? A young and an older person partner each other, and find out a) what work the older person has done in his or her lifetime, and b) what work the younger person hopes or intends to do. One or both of them will then mime their partner's job to the whole group, who have to try to guess what it is. It may be that the partners will not recognize each other's jobs, and will have to help each other with the mime. One 10 year old did not know what a matchmaker was, and her partner didn't know what an archeologist was. So the first part of the game can bring out some interesting conversations.

Things in common and differences By asking simple questions you can discover similarities and differences within the group. You might ask who likes chocolate, or what, if any, football teams people support. If all your group are fairly mobile, you can ask all the participants to group and re-group according to their likes and dislikes, their affinities and differences. If any of the group are not mobile you can use other devices, such as giving out badges for those who are 'in the chocolate-lovers club', or for supporters of a particular team. You can tailor your questions to suit particular groups and individuals.

Creating a song/poem/rap to say hello or goodbye The group leader could provide the first line such as: 'Now it's time to say goodbye...' or 'Here we are and ready to go' and ask all the groups to see if they can come up with a line which rhymes. These can then be put together and learned by the group over the week. Or you could develop a simple clapping rhythm,

A story about finding common ground

Although the children in the project were very local to the Residential Home, none of them had ever been inside, and could not really imagine who might live here. Many of the residents had lived in the locality before coming to the Home, and were aware that there had been many changes over the years. For the first visit the children prepared a large map of the area. They took coloured pins, and stuck them on the map where their older partners had lived. They then took different coloured pins and stuck them on to show where they lived. As well as provoking memories and discussions about changes, many residents found children living in the same streets where they had lived, and a bridge between them was established.

into which people can add some words, for example how they are feeling at the end of a session. Or take a melody that is familiar to everybody and write your own words.

Principles

Use a combination of activities in pairs, small groups and the large group.

Introduce some simple activities which could become rituals, i.e. for greeting and saying goodbye.

Make sure that everybody has met somebody.

Explain activities clearly, bit by bit if necessary.

Be flexible: Some activities will take off, others may not.

Don't expect people to do things you wouldn't do yourself.

Sow seeds for the whole project.

Remember that every aspect counts, not just the organized activities. A lot can happen on the walk to and from the venue, or in an informal conversation between activities.

 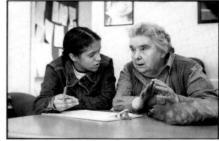

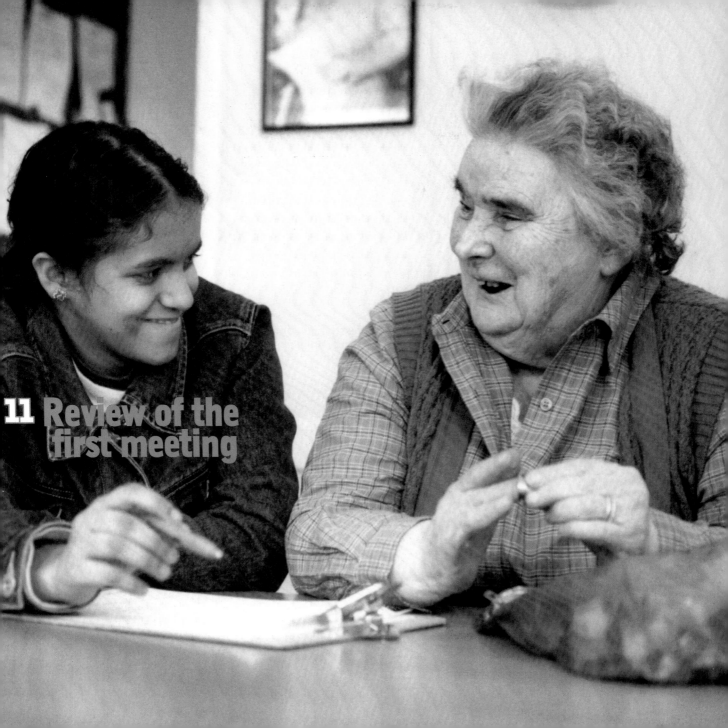

11 **Review of the first meeting**

In this section we look at feedback from first sessions, with the children, the staff, the artists, at school and with older people.

with the children....

At Hill House Nursing Home, we had been offered a room to meet in after the session, to talk to the children about how things had gone. Staff had kindly laid on drinks and biscuits, which most of the children fell on enthusiastically. We quickly re-arranged the chairs so that everyone was sitting in a circle, and we could all see each other. To start us off, I asked each child to see if they could find one word which summed up how they were feeling at the end of the session. Going round the circle to make sure that each one got a turn, out came a variety of responses: "Excited... Tired... Fun... Surprised... Brilliant". Even at this stage we introduced two guidelines for the feedback; one, that only one person could speak at once, and two, that everyone had the right to pass if they didn't have an answer at the time.

These words gave us a starting point for discussion:

"What were you excited by, Naomi?"

"Well, I never thought Billy could really hear me, and then after I'd explained the game he started talking, and telling me jokes, and we had a really good chat."

"Did you manage to write down some things about him?"

"Yes, I've put them into the hand-drawing. I've got more to write in when we get back to school"

"Do you know why you're tired, Dan?"

"I dunno. Meeting lots of new people, maybe"

"There is a lot going on in the room, isn't there?"

"I thought old people would be quieter".

Slowly, all the responses were gathered together, and we moved on to thinking about whether there were any suggestions for what we might do differently. One child said that she'd like to go and collect her partner from her room next week, at the start of the session. Another reported that his partner, Ada really enjoyed playing a percussion instrument, and seemed to have a big store of songs which she could bring to the session. Anima was very quiet, but looked as though there was something on her mind.

"Anima, is there anything else you want to add? Is there anything you found a bit uncomfortable today"

"George wanted to kiss me goodbye, but I don't really like to be kissed"

A few others agree, and some say they liked to be kissed goodbye.

"What could Anima do ?"

"Tell him?"

"No, I'd be embarrassed"

"Put out your hand to shake his hand?"

"Give him your hand to kiss"

She giggles. "Okay, I'll try that"

To finish, I ask the children to tell the group anything which they noticed during the session which they thought was really special. At this first meeting there are only a few suggestions, but as the weeks go by I expect they will notice more and more, and be able to appreciate one another's contributions to the session.

with the staff...

It wasn't possible to meet with all the Hill House staff who had been at the session, as they are on shifts. When the children had returned to school, I met with the Activities Organiser, Errol, and he agreed that he would try to get feedback from them and pass it on to me, and that I would try to catch individuals as and when I could. His first concerns were practical. It had been hard to get the room ready in time, and as a result he wasn't free to go and remind the adults about the session, and many of them were late coming down. We agreed that either my colleague or I would come to Hill House in advance to help with the room, and I reported back to him that one of the children had asked if she could go and fetch her partner and bring her to the lounge. Perhaps others would like to do the same?

Errol thought about it.

"Could one of you go with them ? I'm not sure about children roaming round the building unsupervised."

"Well, between the two of us tutors, and you, and the class teacher, we should be able to."

I agreed to discuss this with Jenny, the children's teacher, and hopefully to try it next week.

Errol had some interesting comments about the adults.

"I never thought that Florrie would join in. She often gets bored and angry. But I think because she always had one person beside her to explain things, she was able to participate."

I told Errol about Amina's embarrassment about being kissed by George. He agreed that she must be able to feel comfortable, but Errol thought that the best approach with George might be to tease him about it. I wasn't sure about

this, but I realised that Errol knows him much better, and he agreed to stand by the following week. Either way, we don't want it to become a huge issue, but we do want everyone to feel at ease.

I had a bit of feedback for Errol. In the preparation stages we did a training afternoon for the three staff who would be involved in the project. However, today, none of them had been there. I felt really frustrated, but I knew that it wasn't his fault.

"Will the three who were at the training session be able to come next week?"

"Yes. I'm sorry about this week. It's a question of scheduling people's shifts."

"But I had understood that they had agreed to organise their shifts so that they could come. It is really helpful to the project to have staff there who have been involved from the preparation stages."

"It's a problem which crops up all the time."

"Is it worth me talking to the Manager?"

"Maybe. It would be good for her to hear it from someone else."

Errol agreed to tell the three staff concerned what happened this week so that they felt up to speed.

with the teacher....

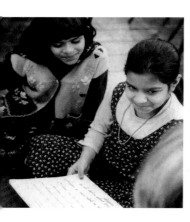

My colleague had walked back to school with the children, and had a chat with the class teacher, Jenny, when the class had gone home. She had some really helpful things to say about the children's involvement, and they looked at ways to help Mona, whose English is limited, get more involved. They agreed to practice some of the activities in class before leaving for Hill House, so that everyone would be clear about what they are doing, which will help Mona feel more confident. Jenny wanted some clarification of her own role.

"I didn't feel sure whether I should stick to supporting the children, or whether it was okay to go and work with one of the adults."

"I think it's great if you get fully involved with the activities, but it is helpful to me if you can also keep some kind of overview. You may notice things which I haven't."

"I'd also like to make sure we have time for me to tell you if anything comes up in class in between the sessions."

"Yes, and I can pass on any feedback from the adults at Hill House. When is a good time to get hold of you?"

Knowing how difficult it can be for teachers to get to the phone, they made a date and time to speak before the next session.

with the older people...

I wasn't able to go back and talk to the older participants on the same afternoon, as they have dispersed by the time the children go back to school. But the next day I called in at coffee time, and found many of them gathered in the lounge. The chairs were clustered in small groups, so I moved from group to group, to have a chat with them about yesterday's session.

Just as I was about to ask one group if they enjoyed themselves, they asked me if the children enjoyed themselves. I reported some of the children's comments, and they were pleased that they were so positive. The group had a lot to say about the children.

"Salma knew a lot about this area, more than I did when I was her age."

"That little chap that sat next to me, he was ever so quiet at first. Was he all right?"

"Are they coming again?"

It seemed hard to get back to asking the adults what they thought, and I realised that they are not as used to 'group discussion' as the children are.

"Is there anything which you did this week that you'd like to do again?"

"The singing. But we don't know the same songs."

"Could you teach them something, and they could teach you something....?"

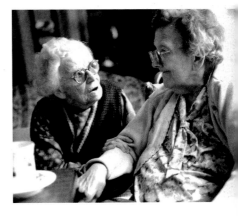

Gerald was a bit put out that his partner, Mustafa, wouldn't accept a sweet. I explained that it was Ramadan, a time in the year when Moslems fast during the day, and that Mustafa was fasting. Gerald was a bit worried about this but, "I remember seeing people eating at dawn when I was in Algeria. Would that be the same thing?" And he promised to ask Mustafa more about it next week.

I had noticed that Bernice was very quiet during the session, and found her sitting alone in the lounge. She is profoundly deaf, but has good eyesight, so we wrote each other notes, and agreed that we would have a notepad ready next week so that she could join in more.

the artists....

For my colleague and I, all that remains is to reflect on the session ourselves: on what had worked well and what had been harder going; on activities I realised I hadn't explained clearly enough; on our plans for the second session, and whether they still seemed right; on the amazing faces of the children and the adults as they started to get to know one another.

12 Evaluation

This section will help you to consider how to check on the progress of your project as it happens, and to assess the project's success when it is complete.

Evaluation of a project needs to:

be enjoyable and energising, not something that feels like a chore

be useful to the participants and leaders working on it

feel useful so that people will take it seriously and give time to it

help people to plan the next stage or next piece of work.

A clear record of the benefits of the project can also help you gain funding or support for the next one. Different organisations use different criteria and methods to measure success. Bear these in mind when setting up systems for documenting the progress of the project, and for evaluating it at the end.

Practicalities

Can a part of each project workshop be set aside for participants to evaluate the work so far, and suggest any changes that need to be made?

For a time of evaluation try to find a private space, so that people can feel relaxed about talking.

Take participants' feedback seriously, so that people are encouraged to contribute again and to risk personal or critical comments. Even small changes to the practical arrangements can show participants their views are respected and will encourage further feedback.

What records are already kept about the young or older participants eg. care plans, attendance registers, records of each pupil's progress? Can these be used to note individual's achievements, problems or reactions within the project? If this is done then the achievements and benefits of the project will be noted officially and kept on file, providing evidence for future support from the institution or from funders.

Build enough time into the project for the final evaluation so that it doesn't need to be rushed.

Project leaders could keep a diary of the project, recording not just what happened, but also things that were said, special or difficult moments. You may think you will remember them, but you don't always.

If you want to take photos or make a video of the work you may need to ask each participant to sign a form agreeing to this (and sometimes pupils' parents or elders' next of kin too).

A story about having a chat

Sometimes talking in a group is too much. Use informal moments to check out how quieter people are feeling. On a visit to a nursing home an artist spotted one girl who was obviously uncomfortable, but reluctant to talk in the group review session. The artist partnered her on the walk back to school and the girl revealed she found the feel of the old people's skin really scary when she shook hands with them. She was ashamed of this feeling and didn't want to tell anyone. The artist was able to reassure her, then brought up the issue in a general way at the next session. When other children admitted their own scared or guilty feelings the girl was able to contribute to a very honest discussion.

Ideas for ongoing evaluation and documenting the work

Clapometer Ask people to call out all the different activities they've done, while you make a list on a big sheet of paper. Then go down the list asking the group to clap in response to how much they liked each activity. The louder the noise, the more they liked it! A good warm up to more in depth comments.

One word answers After a busy session ask people to choose one word to describe how they are feeling. This can help focus on the most important points. Then open things up through talking, drama, drawing...

Diaries or journals Keeping a weekly diary is an excellent way to reflect on what's happening and have a record of your progress when you reach the end of the project. Some people find writing hard and may prefer taped diaries, scrapbooks, drawings or e-mail. Group diaries can be created as part of the weekly review session.

Letter to a friend Ask participants to write a letter as if to a friend (real or imaginary) telling them all about what they've been doing and how they have felt about it. This can generate very personal reactions.

Ideas for the final evaluation

Questionaires and evaluation forms Many teachers and nurses feel burdened by paperwork and will not be keen to fill in more forms or write regular reports. Equally you may find that some young and older people find forms difficult, so they need to be very carefully written and laid out to get useful answers. Prepare them with the teacher, activities organiser or someone else who knows the group well, to make sure the language, layout and questions are appropriate.

Remembering Ask participants to think back through the project, and see what memories surface. These high and low points can help to illustrate the benefits and the learning points in the project.

Numbers Many organisations and most funders will want a record of the number of participants, plus their gender, age, ethnicity and any disabilities.

Criteria All the participating groups need to agree in advance on the criteria for measuring the success of the project. Your original aims are obviously the primary benchmark. Criteria might include:

 level of attendance and participation

 growth in confidence of participants

 growth in skill and confidence in the art form, including critical skills

 increased communication and social skills, including language development, ability to interact within the peer group, and with other participants and staff

 expression of interest in the project outside the sessions

 ability to express ideas and feelings

 quality of the arts component, both process and product

appropriateness of the arts activities to the group

leaders' ability to include, support and encourage participants

benefits to the participating organisations

Some of these will be easier to measure than others. It can be useful to find examples which demonstrate what you are talking about, and to include contributions of the professionals who work with the participants longer term to support your findings.

Principles

Help people to find the language they need to express their ideas, views and feelings. Remember that they may not be used to doing this in a group.

Provide a clear structure so people can explore feelings in a safe way.

Celebrate and praise the group's achievements. Help people to identify why certain approaches or activities have worked so they can be used again.

Don't just dwell on problems. Help people to find constructive ways forward.

For all involved in the evaluation, suggest: 'No criticism without suggestions for change.'

Credit participants when their ideas are used so people feel recognised and valued.

Encourage a culture of evaluation and thoughtful practice from the beginning of the project. If you evaluate when things are going well, its easier to acknowledge and evaluate problems later.

Don't try to evaluate the whole project after the first session.

Don't be afraid of the final evaluation. It can be a helpful opportunity for honest reflection.

In the final evaluation keep a good balance between the concrete information; the facts and figures, and the less measurable aspects; the 'stories' of the project.

Don't avoid evaluating the arts element.

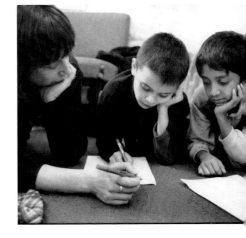

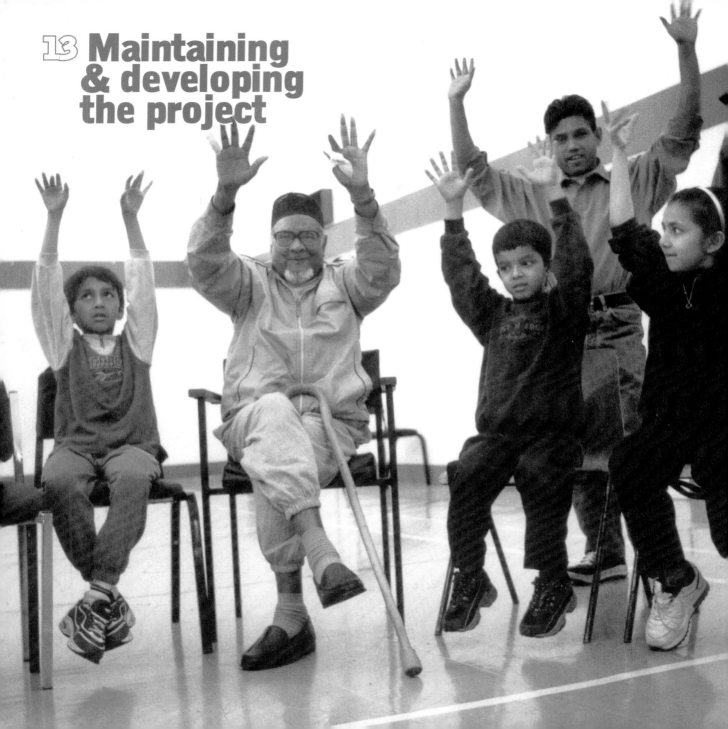

13 Maintaining & developing the project

This section will help you look at how to manage the ongoing project, how to keep up the interest and momentum and what the key stages may be.

After the first meeting of the two groups you begin to see how the project really looks, feels and lives. Whatever the length or structure of your project it has a process to go through, and there is a dynamic which is common to almost all projects.

The first stage is marked by anticipation, caution and excitement, with a slowly growing confidence and enjoyment. Participants are enjoying getting to know one another, and the activities are involving and fun.

The second stage is often marked by a lull in the interest and commitment of some of the group. It can be because the initial excitement has worn off, or perhaps that feelings are beginning to emerge that are more difficult to handle. Sometimes individuals feel that they are not achieving anything, or that they haven't found their place in the group.

The third stage sees the group moving on to greater involvement, closer relationships, a sense of ownership of the project, and pride in what individuals and the group are achieving.

This pattern will be influenced by the kind of project you are running: its duration and the length of sessions; whether you are working towards an end product or not; what art form you are using. It is helpful for the leaders to maintain an awareness of the dynamic of the project and to think about appropriate strategies at each stage.

Practicalities

Regularly review the aims which you set at the start of the project to see whether you are drifting away from them, and need to refocus, or whether they need to be adjusted.

Keep up the regular evaluation of the sessions, with participants, colleagues and staff. They may have some great ideas you could incorporate, and some useful feedback.

Always have one or two extra activities in hand, for the times when the group needs a change of focus, or another activity is not working out.

When you are working towards an end product, it can be helpful to take time out occasionally, and do a game or an activity that is unrelated, and helps people to relax and have fun.

Don't underestimate your group. As you get to know them, keep challenging them to try new things, to extend their skills and to experiment.

Try to keep a balance between sticking to your planned activities in a way which helps the group to feel secure and supported, and welcoming and incorporating eccentricities and spontaneity.

When you hit practical problems, decide how important it is to sort them out. Something that would be impossible to live with in a project which lasts a term may be tolerable in a three day holiday project, and vice versa.

Everyone in the group will at some point be less involved than at other times, but they will often still be happy to watch, to talk or to help someone else.

If you are working with another leader, think about how you can support one another during the session, and help keep the momentum of a session going.

Your resources

You have a lot of resources to draw upon as the project progresses. You have:

the participants The people involved as participants will emerge more and more as individuals with different gifts and personalities. They will make their own contributions, and begin to add their own ideas and influence the project. Perhaps you can ask one of the groups to lead an activity. How can you involve everyone in deciding things about the end product?

For example, when a creative writing project is going to end in a performance or a publication, how could the whole group decide whether they want everyone to have their work represented in the end product, whether the group will choose their favourite pieces, or whether they want to leave it to an editor? Elements of the project can help the participants to develop critical skills, so that they learn how to be able to feed back constructively to one another, to become more confident about judging why one photograph, or poem, or scene, works particularly well, while another one is less successful.

arts activities You can 'keep the brew fresh' in your sessions by adding some storytelling to your music session, or some painting to a drama session. Changing the angle keeps everyone's interests alive, and can sometimes give new opportunities for people to join in. As the project goes along it can be helpful to remind people what they have already achieved, particularly in the second stage 'lull'. Hearing poems, looking at pictures or sculptures, getting photos developed, or hearing each other's stories will all add to the group's sense of worth, and enjoyment of one another. The development of critical skills, as mentioned above, will help people to feel a sense of value in what they are doing. Encouraging a real interest in the art form can prevent the danger of the activities just being an excuse for bringing people together, or as a way of passing the time.

other staff Other staff involved in the project may be able to add ideas, to help practically, and to feed back to you on things they have observed. They may be in a position to follow up activities or issues in between sessions. If they get

involved in and excited about the arts activities, and are learning things for themselves, they will pass their enthusiasm on to the participants and will feel more included. They will also have their own areas of expertise. For example, a member of the care staff could spend time talking with the young people about growing older in general, or aspects such as short term memory loss in particular. A teacher who has been working on a local history project might be able to spend time doing research with some of the adults.

your leadership As leaders you obviously bear most of the responsibility for keeping the sessions going, and for planning them. The ways in which you work together will influence the sessions, for the better if you are able to work in a co-operative, confident and flexible way. This obviously needs lots of dialogue between you, and a shared understanding of the aims of the project. You may have quite different skills. It could be that one of you is an artist and the other a teacher or care assistant. It may be that one of you likes to plan in great detail, and the other prefers to be very flexible with plans. The more clearly you can articulate your ideas and your reflections on the work the better the working relationship will be.

Don't avoid the conflicts and difficulties. Many of the people who have led Magic Me projects have remarked that difficult moments were a turning point in a project, once they had been worked through. Remember to always discuss the good things that happened in the session, as well as assessing things that may not have worked.

diversity of the group Finally, the fact that the project is bringing together people of different ages must be one of your richest resources. It is interesting that when projects do go off the rails it is often because what has been planned is really designed for either younger people or for older people, but not for an inter-generational group.

Principles

Ensure all participants get opportunities to give and to receive.

Give both groups some time apart in order to reflect on what they have been doing in a way that's most appropriate to them.

Don't try to resolve every problem on your own. Work with the participants and your colleagues.

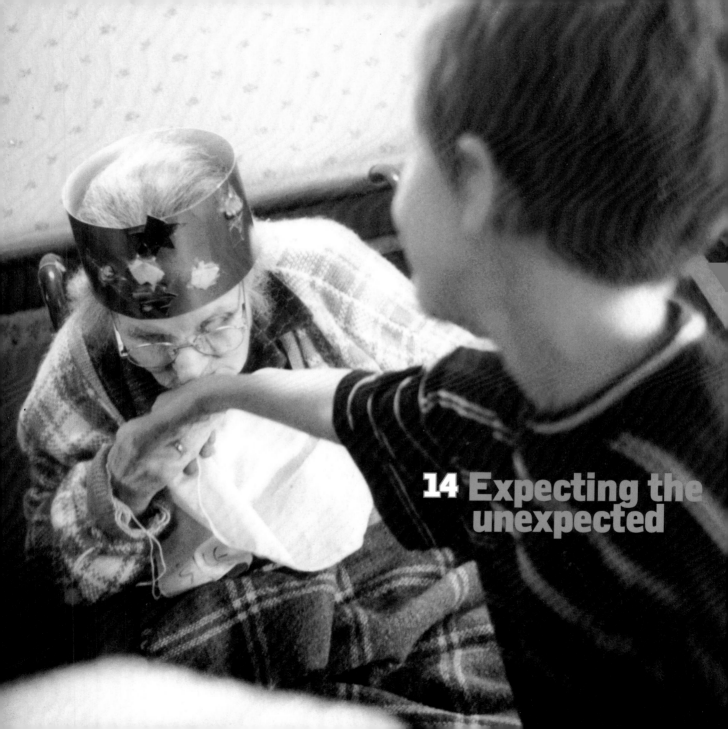

14 Expecting the unexpected

This section will help you to anticipate unexpected situations and developments, consider how you and your partners would respond and prepare yourselves to deal with the unexpected.

The following scenarios are all based on real events during Magic Me projects. Read the scenario and before you consider the given response, think about what you would do in this situation. We are not aiming to give you 'the right answer' and you may come up with a very different approach depending on your training, experience and style of working. The suggestions given are a mixture of what we did and what we wish we'd done! It is of course much easier to come up with a great solution the day afterwards.

Success! Are you ready for it?

A group of pupils have been visiting elders at a nursing home every Wednesday for about six weeks. Strong friendships are growing and some children have started to visit at the weekend as well. Last Sunday one pupil brought along two friends not involved in Magic Me, who didn't know the residents, got bored and started to mess around. When the duty manager asked the children to leave they got very upset and on Monday they complained to their teacher.

What could you do? Magic Me worked with the children, teacher, home manager and residents to devise a system which ensured individual visits could continue and be a pleasure for all. Children in the Magic Me group were given a membership card to show the receptionist and shown how to sign the standard visitor's book. The card made them feel special and 'expert' Photos of the children with residents, taken during the project, were displayed in reception so more staff were aware of who they were. Children consulted residents and drew up a list of times when it was better to visit, avoiding mealtimes, the Church Service etc. They did not then visit, only to be told that residents were too busy to see them and feel rejected. The children asked Magic Me to run activities during the holidays, as when they went to the home on their own, they ran out of things to talk about.

Can I come too?

Nursing home residents and junior school pupils are meeting once a week with a poet, to write poems, aiming to publish a book of their work later in the year. All the 50 residents in the home were invited and about 10 chose

to come, but word has got around that the group is fun and worth a visit. Care assistants, who were slightly sceptical originally, are now keen to see their favourite residents involved and have started bringing them along to join in. The room is getting very crowded and busy and the careful balance of one child to one elder has been lost.

What could you do? No-one will benefit by avoiding the issue. If the activity won't work with more people don't pretend it will, to avoid leaving someone out. Tactfully tell the residents and care assistants "Sorry, we are already full. You can't join this week but we will get back to you".

Arrange a meeting with the key decision makers and staff to find a way forward. Agree clearly the maximum number of residents who can be catered for and clarify why this is. Agree which residents are in the group and a waiting list of others who are interested. The manager needs to confirm with other staff that this is now set and to take responsibility for making sure people stick to the agreement. Someone will need to talk to residents who cannot be included. Can they and the care assistants organise another activity at the same time elsewhere in the building? Some people may specifically want to work with children or a poet; others may just want a social occasion or a group activity. Be careful to note this demand for planning future projects and funding applications!

When the novelty wears off....

After their weekly visit to a local Day Centre, the pupils walk back to school for a 20 minute evaluation discussion with their teacher and one of the project artists. The teacher has arranged to use the school library and this has been fine so far. On the fourth week the teacher is called away to deal with a problem with the rest of his class. In his absence another teacher comes into the library, is annoyed that it is in use and complains that she needs to set up for her after-school Reading Club, starting in ten minutes at 3.30. She has been flexible till now but hadn't realised you were going to use the library *every* Thursday.

What could you do? Acknowledge the needs of the teacher but also make clear that it is important that the pupils are able to finish their discussion and afternoon well, without interruptions. Tell her how long you need to do this and offer help with setting up the room when you have finished. Try not to use all the available time negotiating and suggest you both meet with the class teacher later to resolve this. Re-focus the pupils on their discussion and the day's achievements before they leave.

Talk to the class teacher about the problem and ask him to find and make a definite booking of a suitable space for the whole period for the rest of the project. If the library is the only space a three way resolution must be found. Consider with him ways in which the rest of the staff and pupils can be informed about the ongoing project, perhaps through a special assembly or display of work.

Tactfully remind the teacher he has agreed to be part of the whole project including discussions; his leaving sends a message to the pupils that the review

is an optional, less important part of the work and should only happen in a real emergency.

Will you just 'f off' and leave me alone!

At a nursing home residents have been asked to bring an object that is important to them as a starting point for this week's storytelling session with ten year olds from the local primary school. One resident, Elsie, has forgotten and the care assistant who knows her best goes to Elsie's room and brings back a photograph. The children each begin to ask one partner resident about their object, but as Sam questions Elsie, she can't remember who the people in the picture are and becomes confused and upset. Finally she bursts out "Will you just 'f off' and leave me alone!" Sam looks stunned and goes very quiet.

What could you do? Sam, Elsie and the group all need attention and the leaders will quickly have to take on these different roles, to limit the problem. Depending on how affected they are, Sam and Elsie may need privacy or time out of the group with a supportive teacher, care assistant or friend. Some of the other children and elders may suddenly feel less secure or unsure of what they are doing. The group leader needs to acknowledge that something has happened and that it is being dealt with, then give clear instructions about the activity, so people know what to do next. The elders may want to discuss Elsie's response or express their feelings about the children's visits.

After the session, help the children to discuss what happened and why, supporting Sam who may or may not want to talk publicly. Acknowledge and praise positive responses made by the children and their calmness in dealing with a difficult situation. At the home review what happened with the assistant who collected the photo and other staff involved in the project, referring back to the agreed aims. Check that staff feel clear and comfortable about their role and tasks and agree some ways of supporting residents who may need help to participate, or who take part in their own particular way. Be ready to give extra attention to Sam, Elsie and their partners during the next session.

The play that turned into a book

During August a short drama project for elders using a day centre and local young people led to a devised performance by the young people, based on stories from participants' lives. Evaluation showed that elders and staff were keen for a second drama project, with them performing, which was set up with a local junior school for the Autumn and Spring terms. After a few weeks it has become clear that the elders are not really interested in performing, though they like the pupil's visits and the children enjoy meeting the elders and storytelling, but not acting. Interest and energy in the weekly sessions is decreasing.

What could you do? The teacher, centre staff and project artists need to review the situation and the agreed aims. They may decide to change the aims, but will need to think first about the resources available and how flexible they

can be. For instance now artists are contracted to work for you, the new plan must be one they can deliver. A drama worker may well be able to lead writing workshops as well, but not necessarily. The practical details of materials purchased, rooms booked etc. will have to be taken into account. Check the terms and conditions of any grants you have received for the project, to see if your new plan still fits their remit. If you are in any doubt, check with the funders early on and they will be much more helpful. When you are clear about the range of possibilities consult the group about their preferences, agree fresh aims and begin to shift activities in the new direction.

I'm afraid I've got some bad news

A group of teenage school pupils have been visiting older people living in a continuing care ward at a hospital for six weeks, designing a mosaic to decorate the patio. They have particularly enjoyed the company and jokes of one lady Sarah and on the journey from school, have been rehearsing favourite puns to tell her. As they go into the ward with their teacher and the artist, the ward manager beckons to the adults and says "Could you come over here a minute. There's something I need to tell you"

She says that Sarah died last Friday and apologises for that fact that no-one has informed the school before. It is now Wednesday. She realises this puts people in a difficult position. The pupils are on their way down the corridor to the activity room, where residents are waiting to start.

What could you do? One leader needs to catch the pupils before they go into the lounge and make sure residents are told that the young people are delayed. The other needs to ask for a room where you can all go to tell the pupils what has happened. Decide who will break the news and do so clearly and honestly. Be ready to answer questions about Sarah's illness and death, or ask one of the nurses to join you to do this. You will need to support the pupils, but also to cope with your own reactions and feelings. Give people a time to express their reaction if they want to, but don't be surprised if the news takes time to sink in, or they don't want to talk.

Ask the group if they are still okay to visit the rest of the residents and think through with them, any practical changes to the planned activity and usual pattern of work.

Anticipate with them that it may be a difficult session, and that the other residents and staff too, may be affected by Sarah's death. You may want to start the joint session by acknowledging Sarah, her passing and her contribution to the group, asking residents and pupils to share any stories or memories of her. You may not feel able to do this so soon.

Use the review with pupils to check how they are and to review the rest of the session. The teacher may want to keep an eye on particular young people who may be more affected, or tell their form teachers etc. what has happened. You will have spent the last couple of hours caring for others and coping with a mix of sadness, anger and being dumped on. Look after yourselves. Use the support and supervision systems you set up at the start of the project.

Before you leave the hospital arrange a time to meet the ward manager to find a better system of communicating key information in between visits.

People who do things differently

At the residential home the elders and pupils are working together to make collages, cutting and pasting images from magazines, to illustrate one of the four seasons. One regular participant Abdul who has severe dementia, seems to enjoy the children's visits, but rarely speaks. He often communicates with people by showing them his watch and smiling. Helen, his young partner today, has found 12 pages of watches in a catalogue and both spend an absorbed hour comparing Abdul's watch with the photos, watched by the amazed deputy manager, who has never seen Abdul so settled for so long. As the session finishes the participants show their collages to the group and the teacher says she would love to display them in the school foyer. Helen suddenly realises she has nothing to show and gets very upset.

What could you do? Helen feels left out and different. She needs to feel that her work with Abdul is valuable and valued, that she will get public recognition, alongside the people who have made collages. The teacher, artist and deputy manager could all be involved. Who's opinion will she value most? A group discussion with the other pupils could include talking about what the elders are getting out of the project and how different individuals contribute to its success. If the aims and activities of the project have been equally weighted between building communication and the arts, this will be easier. An exhibition -at the school could give equal status to some of the collages and pupil's writing about other aspects of the work, with a partner exhibition at the home.

Principles

Develop good lines of communication before they are needed.

Use your agreed evaluation methods to develop ways of involving leaders and participants in problem solving from the outset.

If you think something may become a problem, trust your judgement and take action before it does. Involve others at an early stage.

Be clear about the roles and responsibilities of the different leaders and organisations from the outset. Clarify the limits of people's job, their authority to make decisions and who else might therefore need to be involved.

Set clear boundaries for yourself and work within the remit of the project. Find ways to resolve practical problems without being drawn into larger ongoing difficulties such as poor management or unresolved disputes between staff members.

Working in an institution you may come across some practices that you are uncomfortable with. You will have to decide when and how to challenge other people, either directly or through the management systems. On rare occasions you may witness or be told about unacceptable behaviour, abuse or negligence. Seek support to decide how best to report the situation, to limit the impact and help those already affected or at risk.

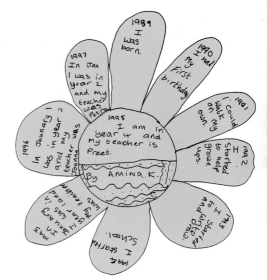

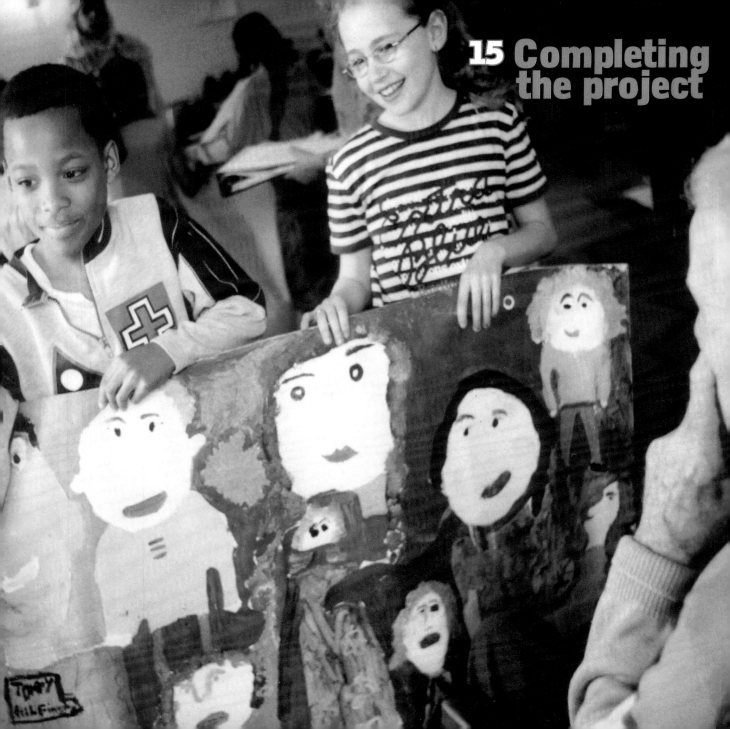

This section will help you to explore different ways of ending a project, consider how the ending of the project will affect everyone involved and think about what might come next.

You probably had an ending in mind when you first planned the project, and you may indeed be committed to a particular end product. However, as the project has gone along, you may want to make some adjustments, to make sure that your ending is really appropriate to the way the project has turned out.

Whatever the scale of your project you will want to celebrate all the work that has gone on, celebrate the relationships which have been formed, and give people the opportunity to say goodbye to one another.

Practicalities

Engage the participants in the preparations for the ending.

Make time at the end to acknowledge the feelings of participants.

Make sure that the implications of a particular end product, (ie mounting an exhibition, completing a video film, putting on a live performance) are made clear by the arts practitioner(s).

Decide whether there are tasks you will need expert help with, (ie editing a video, creating display boards, preparing a book for publishing).

Saying thank you and acknowledging people's contributions will mark the ending in a positive way.

Consider what is going to happen any artwork, photos, written work etc. that has been produced in the project. Who is going to keep it, and where?

If you have been working with an ethnically or culturally diverse group, try to reflect this in the completion of the project.

Food and drink are a great ingredient, but check what all the participants can eat and drink first.

For some participants it can be really valuable to have a certificate marking their involvement in the project. Discuss this with relevant staff.

A story about mixed ambitions

When I was planning a project which would involve a group of young women, I met up with their Youth Worker. She seemed quite cautious, suspicious even. She asked a lot of questions, and told me that she really didn't want to work on an arts project at all. The year before she had been involved in a visual arts project, where young people were to be involved in creating a mural.

The project had started off well enough, with art workshops which were exciting and accessible. However, as the project got nearer to the point at which decisions had to be made about what would go into the final mural, the whole atmosphere had changed. As she saw things, the participants' work was now assessed much more critically, and the artists took over more and more of the design and execution of the mural. Finishing the end product became much more important than the process of creating it, and the participants were not offered the support they needed to complete it themselves. The young people could feel that they were no longer essential to the project, and numbers went down dramatically.

What could you do?

A party, an exhibition, a concert, a performance, a puppet show, a video showing, a public reading, a dance, a play, a quiet evaluation......

The art form which has been the focus of your project may make the choice for a final event obvious. A performance, exhibition or book launch will provide a wonderful high point, but it won't give people the opportunity to say goodbye, and to evaluate the project. You could build in a final session after the big event when this could happen.

You may have done a project using a variety of activities which do not lead to an end product. You could plan a party which includes an opportunity to revisit favourite activities and games. Participants can use the final session to appreciate one another through poems or drawings or songs.

If you are doing a long term project, with no definite ending planned, you may well need to build in some highlights during the life of the project, where work and relationships can be celebrated.

Whatever you do will need some planning. It won't just happen. Be prepared for a significant increase in your workload if you are preparing for an event at the end of a project. Plan an ending which is appropriate in scale, style and content to the project and doesn't over extend your capacity to deliver it, or cause you stress. Share tasks as much as possible so that everyone can enjoy the event.

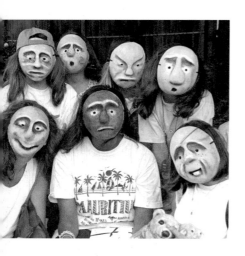

Who will come?

Your final session may be something that is only for the participants who have been involved all along. Sometimes both older and younger participants may want to be able to invite family members, but be cautious about inviting the young people's peer group from school. Check with the teacher whether they might feel self conscious with such an audience.

You may want to open it to a wider audience, by inviting people local to the partner groups, or relevant professionals involved in the arts, education or health. Some end products lend themselves to open invitation, for example an exhibition of photographs or artwork. In this setting it helps the audience if you have information about the background of the project, using display boards, a leaflet and/or taped or videoed contributions from participants.

Where will it be ?

Many people will feel happiest if the final event is in the same space they have used for the regular sessions, or you may want to move to another room in the same building. You could do something in the 'home base' of each group.

However, if the final event needs to be somewhere else, try to give participants the opportunity to visit the new space in advance, particularly if they are going to perform there. It can be very exciting for participants to see their work in a new place, and don't be afraid to ask for prestigious spaces, such as the local art gallery, the Town Hall, local theatre, the headquarters of a business. Check that they have what you will need (sockets, disabled access, tea...)

Inviting the press to your final event

Most participants will be excited and keen to be featured in the local press or media, but you need to make sure that your story is covered in an appropriate way and that the facts are right.

If you haven't dealt with the press before, get advice from someone who has. Check any information you give out with all the organisations involved. They may have guidelines or protocols which need to be followed. Have a typed information sheet or press release to give out, with all the relevant information. Make sure that the right people have been acknowledged. Be careful to get the permission of any participants who may have their photos used in the press.

Don't let the press interfere with your final event. It may be better to offer them a time before or after the event to do interviews or take photos. Some press photographers will want to set up shots which emphasise the sentimental interest in young and older people doing things together. This isn't always negative, but if you want to present a particular aspect of the project, invite photographers to record this, or get your own photographs taken to send to the press.

Feelings

There will be a variety of feelings about ending. There will certainly be some sadness, and a sense of loss. For some, there will be feelings of relief, even if they have enjoyed themselves. By now you will already have established a framework for feedback and evaluation. Use this to give everyone the opportunity to think about the experiences of the project, to name the learning, and to say their farewells. By now you will know your group well enough to judge the level of this sharing. It is important to find a balance between acknowledging the feelings which are present, and allowing people to say only what feels comfortable for them. It may not be possible to have this kind of discussion at the final event, so you may want to plan a visit after this which is just for evaluation and discussion. Some things may be more easily expressed if you talk to the two groups separately. If you sense that certain individuals will need more time to talk, or more support, you will need to alert the staff who work with them long term. Staff and leaders who have been involved will also need a chance to debrief and evaluate the project.

What next?

As the project comes to a close, the issue of what will come next often emerges. Sometimes some very clear recommendations for the future will surface, sometimes there will be the germ of an idea for future creative work. Try to be realistic when you respond to requests for future projects, and don't promise something that you may not be able to provide. If another similar project is not possible, there may be other ways to continue the contact between the two groups, so long as there is someone to organise it. If you do want to go ahead with another project you could involve the participants

A story about trust

During the project all the participants had joined in with creating songs and stories about the seaside, with the idea of performing them at the final session. We had put together costumes, and painted some scenery, and invitations had gone out to friends, relatives and other residents of the Home. There was a lovely feeling of anticipation. However, in the final weeks of preparation, several of the older participants decided that they didn't want to perform after all. At first we thought of putting a lot of energy into persuading them to change their minds, but instead we decided to leave it open. By now the young people were confident enough in what they were doing, and knew their partners well enough, to be able to be flexible in the performance. On the day itself all the potential performers sat in the front row. Rose and Reuben, who had said that they wouldn't perform, got up and joined in after all. Ruby sang from where she was sitting. Etta joined the curtain call, although she hadn't performed on that day, which felt fine, since she had been part of all the preparations. The applause was long and heartfelt.

in more of the planning. You may want to work with different people from the same two institutions, or you may want to build on the experience you have just had with the same people. It can be valuable to take stock again a month or two after the project is happening to see how people are feeling about future projects then.

For the leaders, the ending goes on longer than for the participants. You will have tidying up and sorting out to do, the budget to balance, and perhaps a report to write for funders. After the excitement of the project's finale, you may find these tasks a bit of a chore. The up side is that this time can be a great opportunity to reflect on what has happened, to evaluate, to say your own goodbyes and thank yous, and to start thinking about the next project!

Principles

Look for a way of ending which gives a sense of completion, bringing together the threads of the project.

There is always something to celebrate, however big or small the scale of your final session.

Show the group's creative work to the best advantage.

Beware of excessive sentimentality.

All endings should include opportunities for leave-taking.

All endings should contain an element of thinking about the future.

Don't regret what you can't do, enjoy and value what you can.

Further reading

The Arts and Older People
A practical introduction
by Fi Frances
Age Concern, England, 1999 ISBN 0-86242-222-1
Includes contact details for many useful arts, funding and other organisations.

Generating Community
Inter-generational Partnerships Through the Expressive Arts
by Susan Perlstein and Jeff Bliss. Elders Share the Arts, New York, 1994
Inspirational workshop ideas and stories.
Available from the Centre for Creative Communities: 020 7247 5385